Hieronymus

Bosch

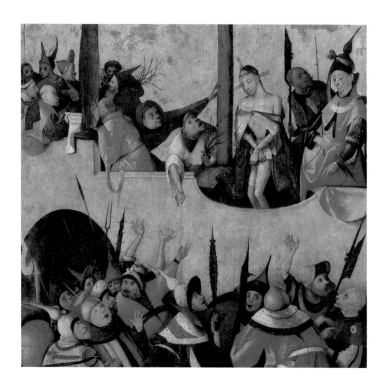

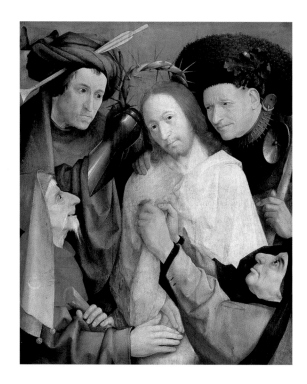

© Confidential Concepts, worldwide, USA, 2004
© Sirrocco, London, 2004 (English version)

Published in 2004 by Grange Books
an imprint of Grange Books Plc
The Grange Kingsnorth Industrial Estate
Hoo, nr Rochester Kent ME3 9ND
www.Grangebooks.co.uk
ISBN 1-84013-657-X
Printed in China

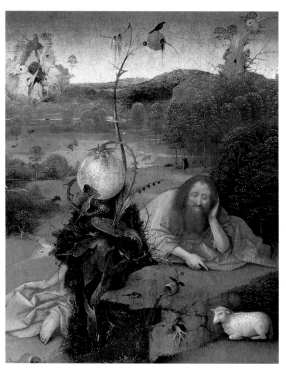

Hieronymus

Bosch

Grange BOOKS

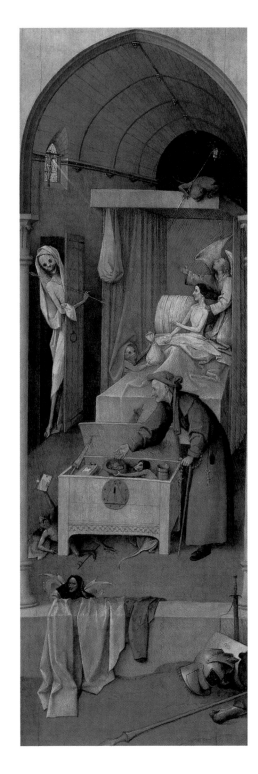

HIERONYMUS BOSCH and the LISBON "TEMPTATION": A VIEW from the 3rd MILLENNIUM

In 1951, Wilhelm Fränger's tome, *The Millennium of Hieronymus Bosch: Outlines of a New Interpretation*, was translated into English. The book created a sensation, both on the scholarly and the popular levels. An article on the book accompanied by color illustrations in *Life Magazine* probably did more than anything else to popularize Bosch, because there had been little or nothing of the sort published on him at the time. Fränger's interpretation that Bosch did his major altarpieces not for orthodox religious purposes, but for use by quasi-religious cults was being promoted as a turning-point in the understanding of this enigmatic artist.

While most art historians who have taken up Bosch in the years since Fränger's death in 1964 have renounced Fränger's contentions, there are still some who continue to endorse his assertion that the grand master of a cult of Adamites dictated its secret imagery to Bosch which he then revealed in his great painting in the Prado Museum, *The Garden of Earthly Delights* (p. 26-27), and in several minor paintings.

The writers who commented upon Bosch in the nearly five centuries following his death compounded such a reputation for the man as a *"faizeur de diables"* (Gossart), that until the modern period he was hardly considered an artist at all.

It was largely his frenzied hell scenes that attracted such attention. When he depicted the creatures and settings of these "hells" in terms of infinitely detailed naturalism, they were so convincing as to seem pure evocation.

To the medieval mind, the man who could reveal so plainly its own worst fears must have been a wizard or a madman, perhaps the tool of the Devil himself. Later writers either reflected this point of view or, following the rationalist aftermath of the Renaissance and the Reformation, passed Bosch off as representing the worst of Medievalism.

When he was mentioned it was not so much as an artist, but as a freak performer. Eventually Bosch was obscured and forgotten. It took at least two centuries until there was a revival of interest in him, in the late nineteenth century.

1. ***Death of a Miser***, oil on panel, National Gallery of Art, Washington (said to have been hanging over Philip II's bed in the Escorial at the time of his death; now said to have been part of an altarpiece)

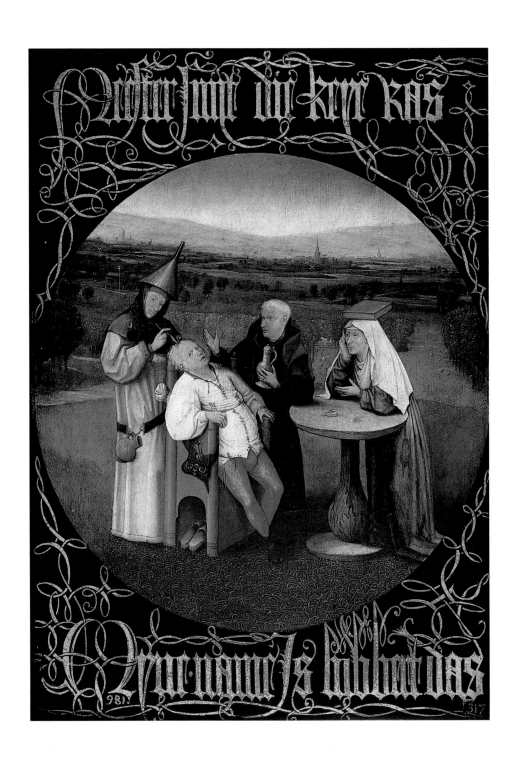

2. *Cure of Folly*, also called *The Extraction of the Stone of Folly*, oil on panel, 48 x 35 cm, Prado Museum, Madrid

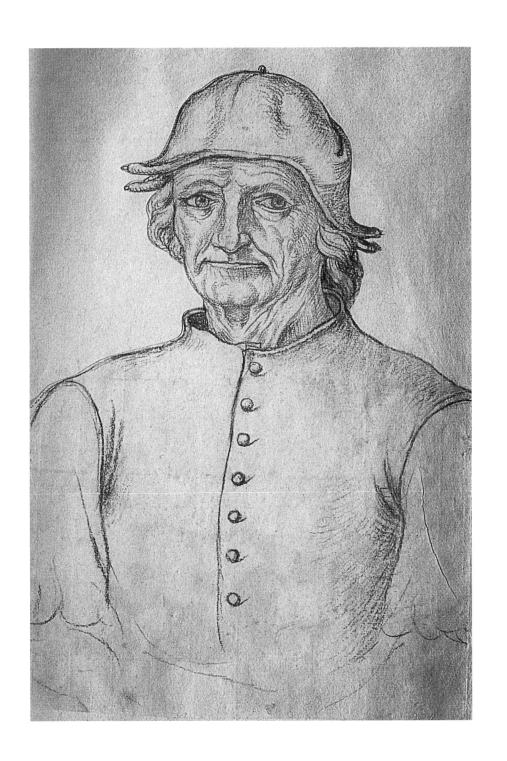

3. Anonymous, ***Portrait of Hieronymus Bosch***, c. 1550. Red and black chalk drawing in the Arras Codex, 41 x 28 cm, Municipal Library, Arras

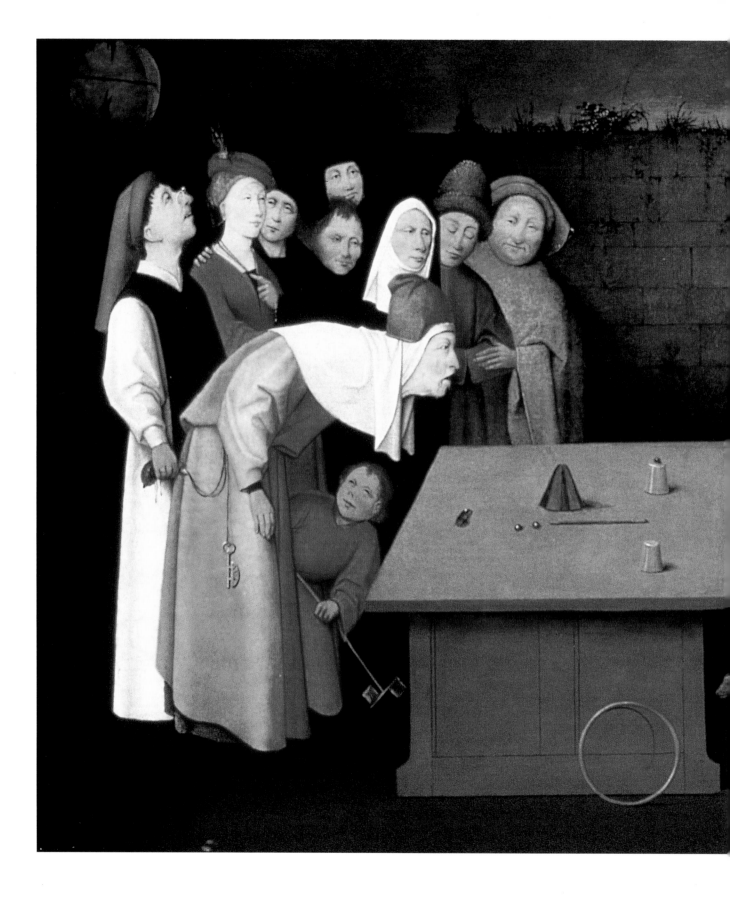

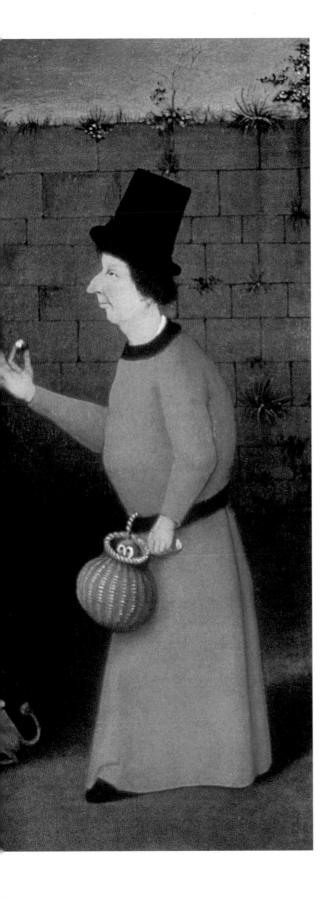

4. *The Conjurer*, oil on
 panel, 53 x 65 cm,
 Municipal Museum, Saint-
 Germain-en-Laye (Ph. L.
 Sully-Jaulmes)

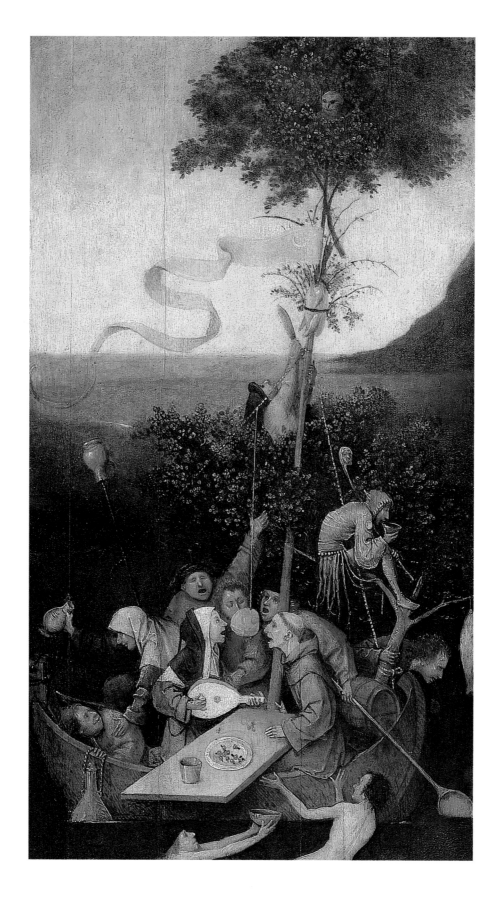

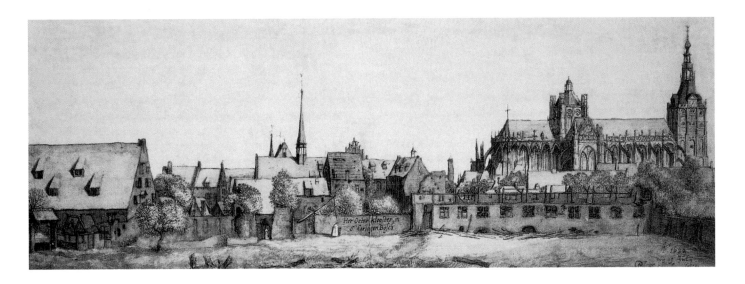

The twentieth century saw more emphasis on this man as an artist than at any time in the past and there is continued, almost overwhelming interest in him in the twenty-first century. One would expect Italian writers of the High Renaissance period to point out the painter's strangeness, since his ideation was so antithetical to that of the South.

The Florentine historian Guicciardini, in his *Description of all the Low Countries* (1567), referred to "Jerome Bosch de Boisleduc, very noble and admirable inventor of fantastic and bizarre things...." In 1568, the Italian historian of artists, Vasari, called Boschian invention "*fantastiche e capricciose.*"

Lomazzo, the author of the *Treatise on the Art of Painting, Sculpture, and Architecture*, first published in 1584, spoke of "the Flemish Girolamo Bosch, who in representing strange appearances and frightful and horrid dreams, was singular and truly divine."

During the same period in the North, similar statements were made concerning the painter's work, his demons and hells being mentioned to the exclusion of all else. The Netherlandish historian, Marc van Vaernewijck (1567), called Bosch "the maker of devils, since he had no rival in the art of depicting demons."

Carel van Mander, the Northern counterpart to Vasari, made little more observation of Bosch's entire works than that they were "...gruesome pictures of spooks and horrid phantoms of hell...." Numerous statements in the same vein began to appear in Spanish writing following the influx of so many of Bosch's paintings into mid-sixteenth-century Spain.

5. *Ship of Fools*, 57.9 x 32.6 cm, oil on panel, Louvre, Paris

6. Pieter Jansz Saenredam, *Drawing of Bois-le-Duc*

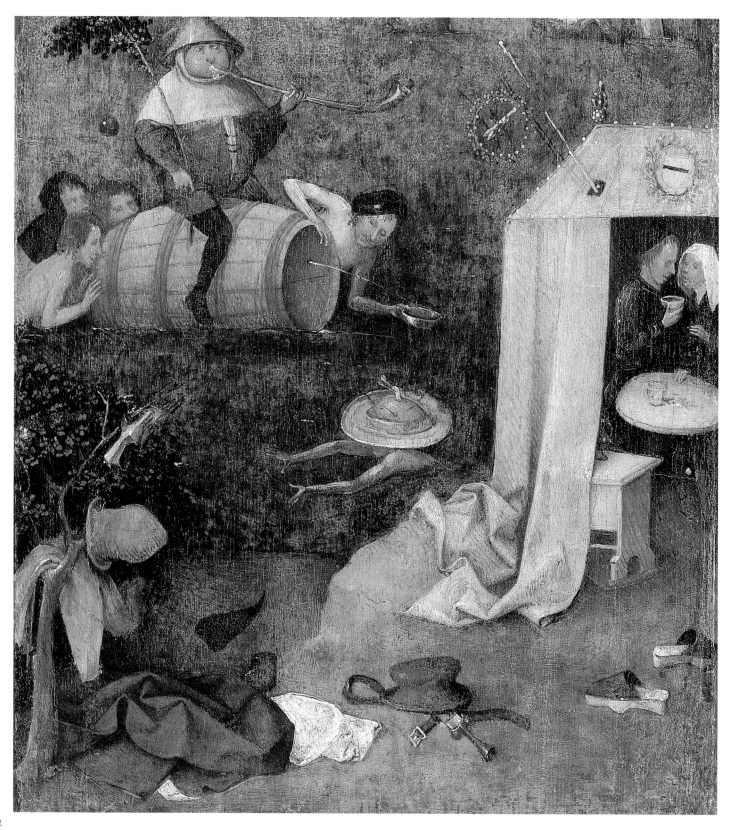

King Philip II, himself, was chiefly responsible for the painter's popularity in Spain. Philip owned as many as thirty-six of these paintings, amazing considered that Bosch's entire output is believed to number barely forty.

Such a large collection, accumulated in so few years after the painter's death, attests to a fascination on the king's part - a state of mind that prompted some of the first penetrating writing on Boschian work.

This was because the monk, Joseph de Siguença, who inventoried the king's paintings shortly after Philip's death in 1598, felt compelled to apologize for the king's obsessive interest in Bosch. Perhaps Fray Joseph feared a destructive attention of the Inquisition, because he wrote an elaborate defense of the painter's orthodoxy and fidelity to nature: "Among the German and Flemish paintings which are, as I say, numerous, many paintings by Jérôme Bosch are scattered throughout the house (Escorial); I should like to speak for different reasons a little longer about this painter, for his great genius deserves it, although in general people call his work absurdities..., people who do not look very attentively at what they contemplate, and I think for that reason that he is wrongly denounced as a heretic - and to begin there - I have of the piety and zeal of the king, our founder, an opinion such (that I think that) if he [Bosch] had been thus, he [the King] would not have admitted his paintings in his house, in his convents, in his bedroom, in the Chapter of his orders, in his sacristy, while on the contrary, all these places are adorned with them.

Except for this reason, which seems very important to me, there is still another which I deduce from his paintings for one sees almost all the sacraments and ranks and degrees of the Church there, from the pope to the most humble, two points where all heretics falter, and he painted them with his zeal and a great observation, which he would not have done as a heretic, and with the mysteries of our Salvation he did the same thing.

I should like to show now that his paintings are not at all [absurdities], but like books of great wisdom and art, and if there are any foolish actions, they are ours, not his, and let us say it, it is a painted satire of the sins and inconstancy of men".

An interesting counter-reaction to that of the monk is the statement by Francesco Pacheco - the teacher and father-in-law of Velasquez - as written sometime later, in 1649:

7. *Allegory of Gluttony*, 36 x 31.5 cm, Yale University Art Museum, New Haven

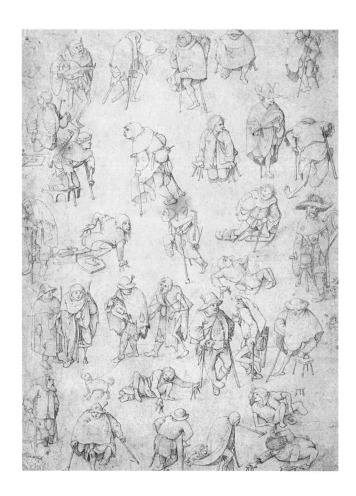

"There are enough documents speaking of the superior and more difficult things, which are the personages, if one finds time for such pleasures, which were always disdained by the great masters - nevertheless some seek these pleasures: that is the case for the ingenious ideas of Jérôme Bosch with the diversity of forms that he gave to his demons, in the invention of which our King Philip II found so much pleasure, which is proved by the great number of them he accumulated. But Father Siguença praises them excessively, making of these fantasies mysteries that we would not recommend to our painters. And we pass on to more agreeable subjects of painting...."

Pacheco was a Spanish painter and art theorist of the artistic period between Mannerism and Baroque. He had rejected the manneristic delight in mere form and was turning toward an interest in naturalistic illusionism.

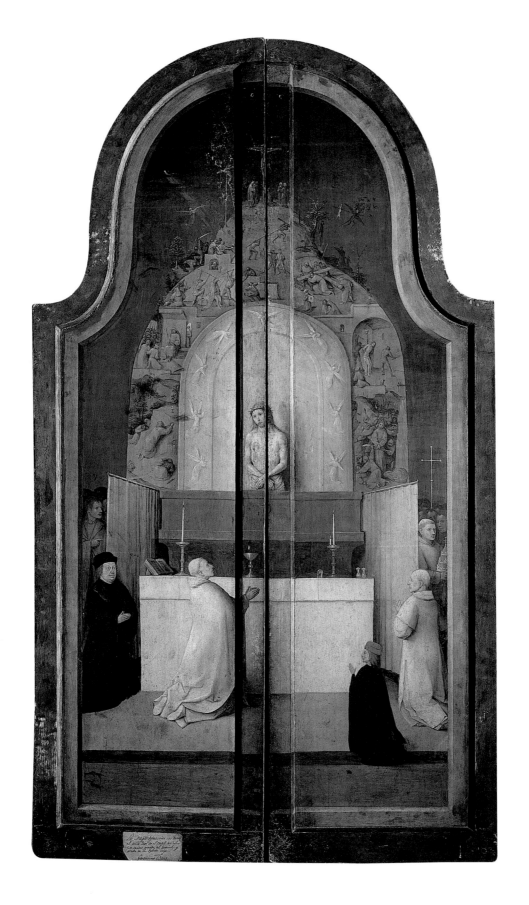

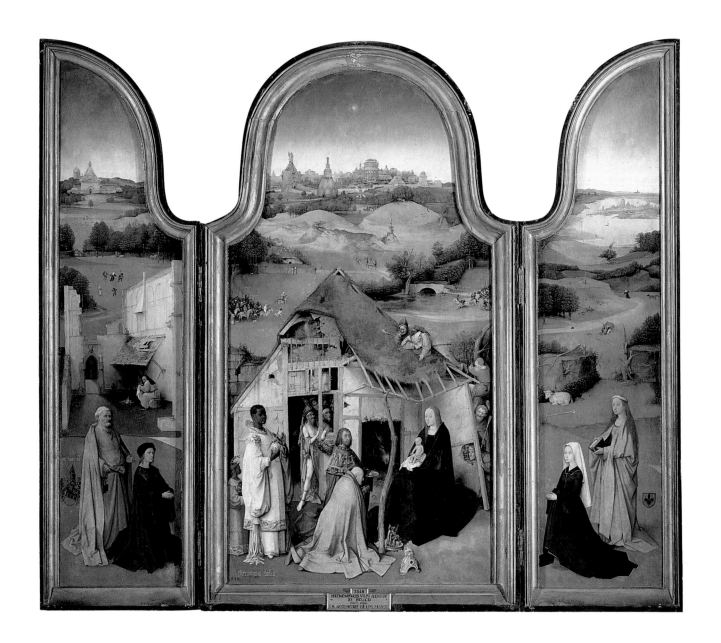

10. ***The Epiphany or The Adoration of the Magi***,
triptych, oil on panel,
138 x 72/144 cm, Prado
Museum, Madrid

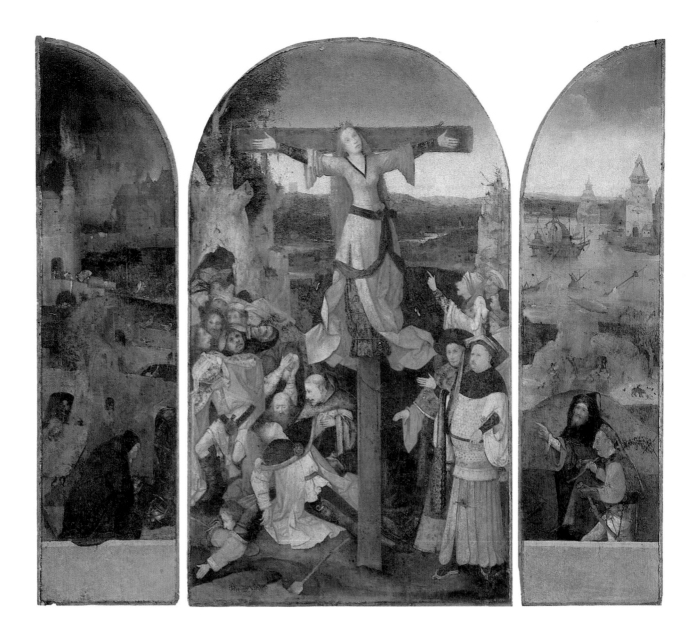

11. *Martyrdom of Saint
Julia*, 104 x 119 cm,
Ducal Palace, Venice

From either point of view he would have found Bosch's work unacceptable. Even though Pacheco's concern was with Bosch as an artist, he passed him off as an oddity, and this reputation clung round the painter for two and a half centuries to come.

During this period there was little attention given by scholars to Northern art at all; when it was considered, Bosch was obscured by the great Netherlandish painters ranging from Van Eyck to Brueghel. It was not until the end of the last century that any respectable scholarship was brought to bear upon the painter.

Perhaps this was a consequence of the realistic impulse that entered mid-nineteenth-century painting. Historians began to look for precursors to this realism in the past. They turned again to an interest in Northern art and in reemphasizing Brueghel, "discovered" Bosch.

Such historians as Ebeling and Mosman sorted through the aged registers of his native town 's Hertogenbosch, a Dutch town near the German border, but the result was disappointing. The date of Bosch's death was discovered in a registry of names and armorial bearings - listed as 1516.

His birth date was not found, but because his portrait, which was discovered in the Arras Codex, showed a man of about sixty, his birth was assumed to have been around 1450. There are a few references to Bosch between these dates in the archives of the Brotherhood of Our Lady at 's Hertogenbosch.

Several items referred to his having been paid various sums for works commissioned of him. None of this was very informative about essential details of Bosch's life, save that, since he was referred to once as "illustrious painter", he was obviously held in repute as an artist by his fellows.

There is no reason to think, from these references at least, that his friends considered Bosch either a wizard or a madman. As to his ancestry, since Bosch's name often bore the suffix van Aken, it was believed that his forebears were from Aachen, just over the Dutch-German border. Five van Akens were mentioned in the town records before the time of Hieronymus. One, a teacher named Jan van Aken, was noted in the archives of 's Hertogenbosch's Cathedral of Saint John in references covering several years (1423-1434).

12. *The Crowning with Thorns*, oil on panel, 73.7 x 58.7 cm, National Gallery, London

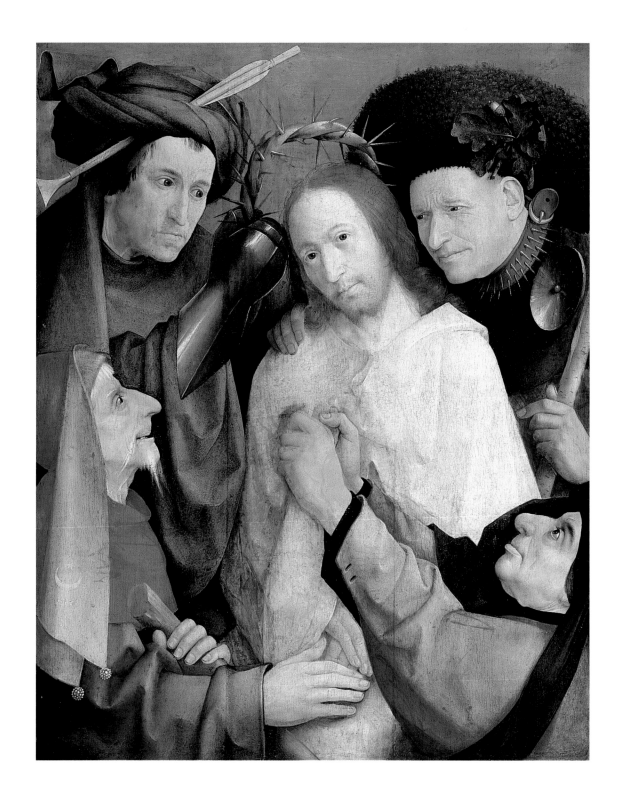

13. Exterior view of **Christ Carrying the Cross**, oil on panel, 57.2 x 32 cm, Kunsthistorisches Museum, Vienna

14. **Christ Carrying the Cross**, oil on panel, 57.2 x 32 cm, Kunsthistorisches Museum, Vienna

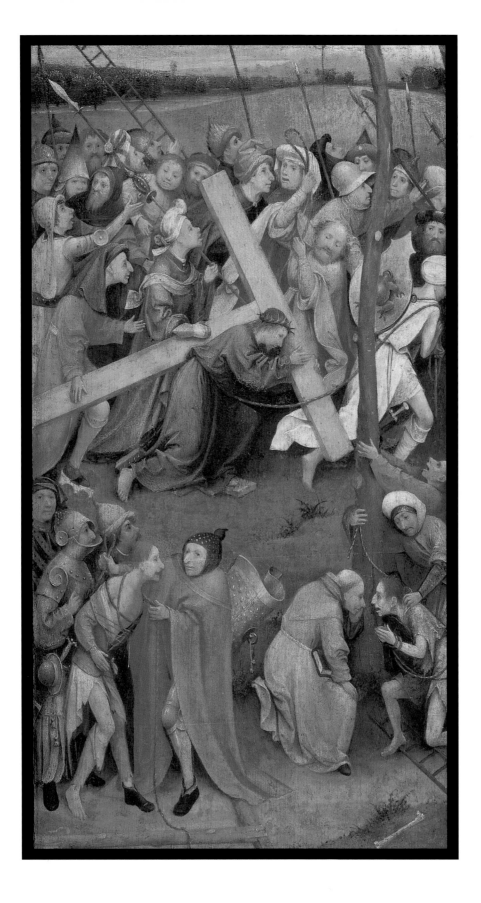

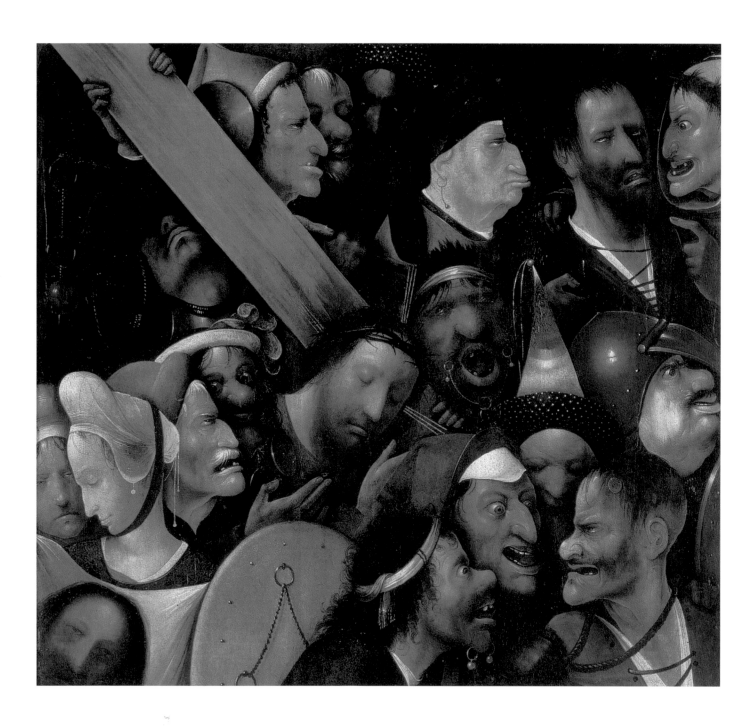

The historians believed that this was the grandfather of Hieronymus and probably the artist of the fresco of the cathedral - considered to be a prime influence on the grandson. In 1464, Laurent van Aken, possibly the father of Hieronymus, was referred to as a citizen of 's Hertogenbosch. This was the extent of the factual data referring to the artist.

The historians were forced to turn back to the evidence of the paintings themselves - but none of them was dated and none was mentioned in contemporary writing. Not until Charles de Tolnay's definitive treatise, written in 1937, was a satisfactory chronology even established, or the works by Bosch's own hand separated from those of his disciples or copyists.

De Tolnay bore directly on the technical evidence of the paintings. He noted that the beginner is betrayed by archaism - stiff figures, long-waisted and with awkward gestures, having no true existence in space nor relationship with one another and the background, and with few and arbitrary folds in their clothing.

By observing such characteristics in some Boschian works, he was able to trace a convincing development from the obviously youthful to those of undoubted antithesis in style and conception. De Tolnay successfully demonstrated that Bosch developed consistently into a great landscape painter and a superb colorist.

Although he never achieved the suavity of an Italian High Renaissance master, in later works he even created a *sfumata* effect, which unified figures and background into a harmonious entirety. De Tolnay's work in this direction was so convincing that subsequent writers accepted his classifications as almost incontrovertible.

There have been exhaustive attempts to clarify subject matter as well. In de Tolnay's words: "The oldest writers, Lampsonius and Carel van Mander, attached themselves to his most evident side, to the subject; their conception of Bosch, inventor of fantastic pieces of devilry and of infernal scenes, which prevails still today [1937] in the large public, prevailed with historians until the last quarter of the 19th century."

Then those historians who saw in the painter a precursor to realism, swung completely in the other direction. They studied his works according to exterior influences such as literature, the artistic tradition of the North, historical events, and the medieval interpretation of the Bible.

15. ***Christ Carrying the Cross***, oil on panel, 76.7 x 83.5 cm, Museum voor Schone Kunsten, Gand

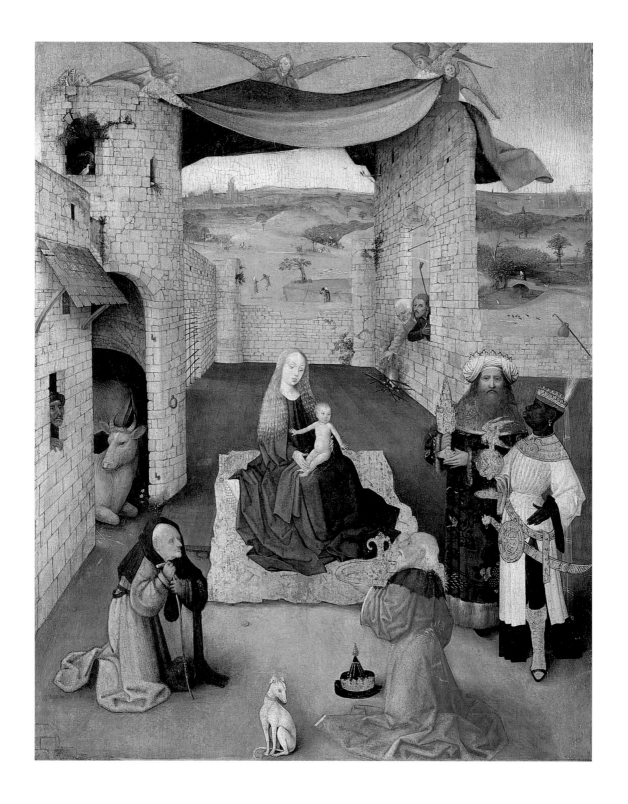

None of these sources produced any conclusive results on the meaning of Bosch's cryptic imagery.

Again in this realm, one of the finest studies was that of de Tolnay. He went far in establishing current influences that would account for much of the Boschian iconography. Most importantly, he introduced a knowledge of Freudian psychology, revealing Bosch's remarkable presentiment of this science.

Jacques Combe followed de Tolnay's lead in his treatise, translated from French into English in 1946, and continuously acknowledged his indebtedness to the prior monographer, but his study was no mere imitation. He suggested many sources of symbolism overlooked by de Tolnay, such as alchemy and the tarot game.

He made a strong case for association between Bosch's ideology and that of the fourteenth-century Netherlandish mystic Jan van Ruysbroek. A Ruysbroek follower, Gerard Groote, had spread his master's teachings by founding the *Association of the Brethren of Life in Common*, numerous orders of which flourished in the fifteenth-century Netherlands.

Since two schools of this order had been established in 's Hertogenbosch in that century, Combe believed that Bosch might well have been influenced by their teachings. He supported this idea by quoting many passages from Ruysbroek's writings, which would seem to throw light on certain images in the paintings. With such respectable scholastic attention, Bosch had finally come into his own in the mid-twentieth century as a significant artist.

His works were seen not merely as an influence on Brueghel, but as extremely interesting in themselves. They were a deviating but appropriate link within the "Flemish tradition" in painting, with its curiously combined naturalism and symbolism. The work of de Tolnay, together with the increasing interest in Surrealism, had inspired popular interest in Bosch as a painter of the imaginary.

Several articles on Bosch were then published in the most popular American periodicals, as well as in magazines of art. The popular articles presented Bosch as an interesting, almost freakish fantasist of the past and a precursor to Surrealism in his "queerness."

16. *The Adoration of the Magi*, tempera and oil on panel, 71.1 x 56.5 cm, The Metropolitan Museum of Art, New York

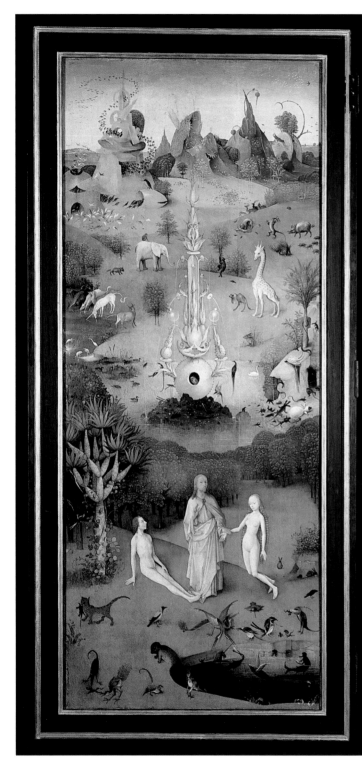
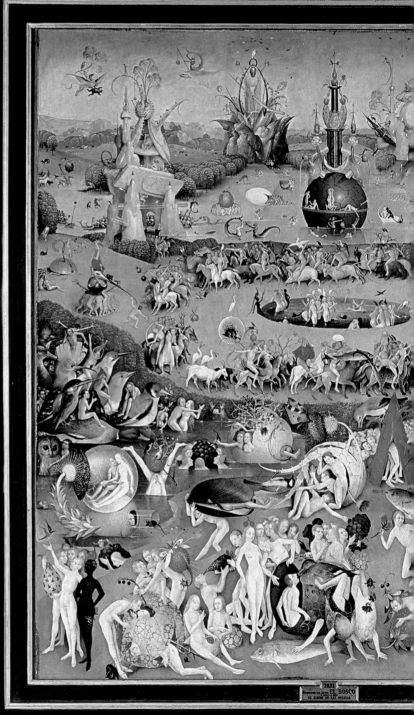

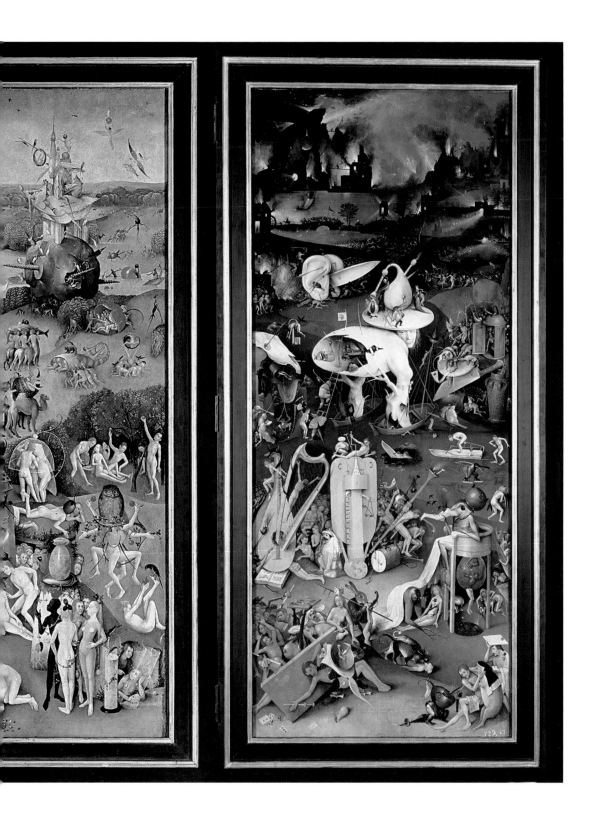

17. *The Garden of Earthly
 Delights*, triptych,
 220 x 390 cm, open: left,
 Paradise; center, *The
 Garden*; right, **Hell**.
 Prado Museum, Madrid

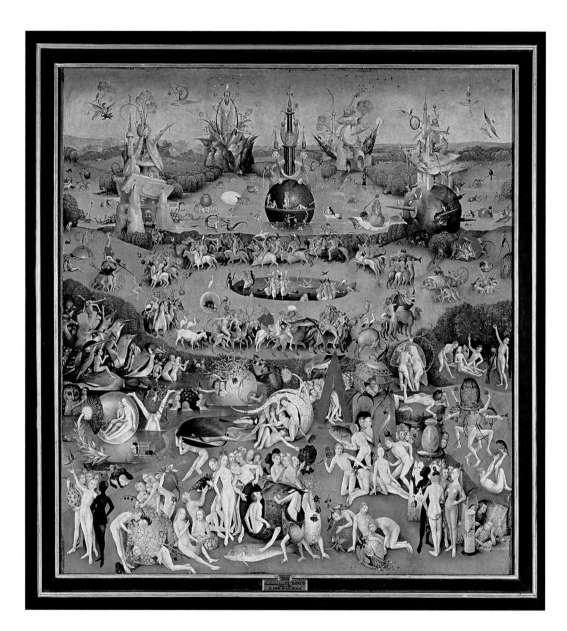

18. ***The Garden of Earthly
 Delights***, triptych,
 220 x 390 cm, open: cen-
 ter, ***The Garden.*** Prado
 Museum, Madrid

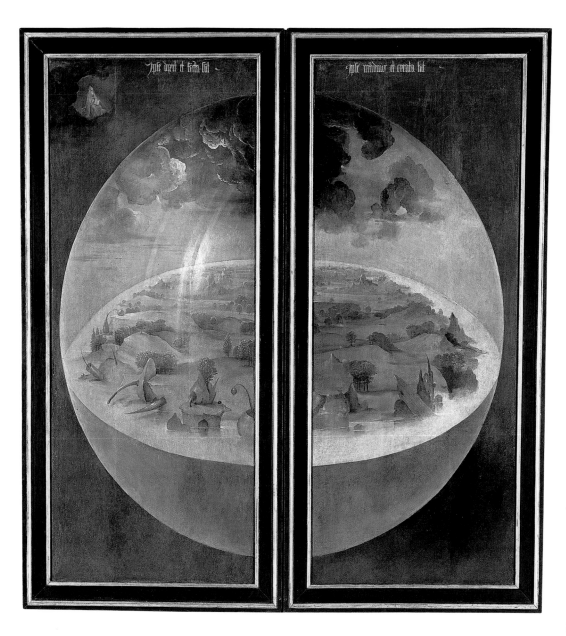

19. Exterior view of *The Garden of Earthly Delights*, triptych, 220 x 390 cm

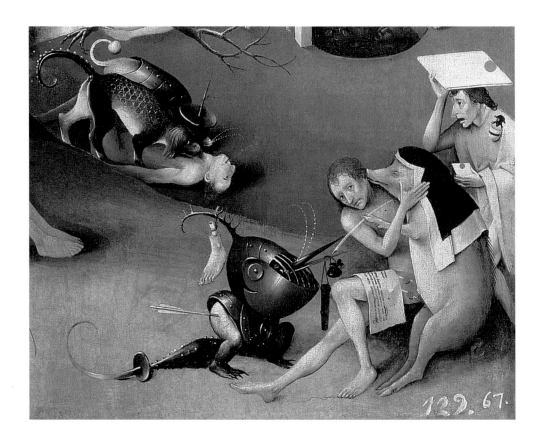

In a few books written in English as well as translated into English, the more scholarly authors continued to search for the exact sources of Bosch's symbolism in outside material. Their implication was that Bosch's symbols, however enigmatic, illustrated images already formed in literature or tradition, and that with enough study these sources would eventually be brought to light and his imagery made comprehensible.

With the 1947 German edition and its translation into English of Wilhelm Fränger's book *The Millennium of Hieronymus Bosch*, published by the University of Chicago in 1951, Boschian research took a new direction. Fränger, too, felt that the answer to the artist's mystery lay outside the realm of art - but instead of *many* sources of his symbolism, he saw only one.

None of the historians had conceived the idea, he asserted, that Bosch might have been obscuring his imagery with a secret purpose in mind - that of presenting the message of the community he belonged to.

20. Detail of the right panel of *The Garden of Earthly Delights*

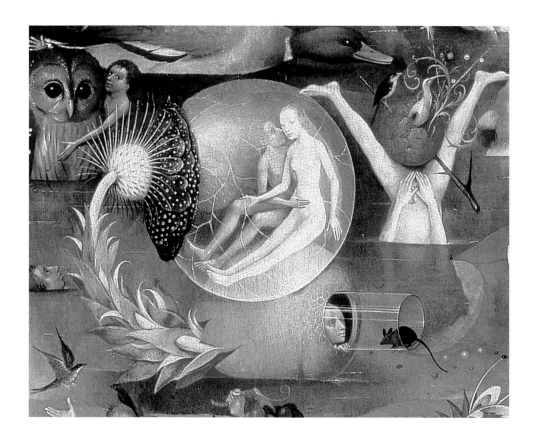

If this were true, the answer to the painter's enigma would lie in one place rather than in many. Fränger, in fact, called all previous studies of Bosch's work into question.

Dissatisfied with their overemphasis on the painter's demons and hells, he believed that neither the separate hell scenes nor the paintings as a whole had ever been understood in their proper context. Thus, his was a radical departure from all previous interpretations.

Wilhelm Fränger began his study of Hieronymus Bosch and his work by deploring the "vulgar misunderstanding" to which the master had been subjected by having his work passed off as mere mummery.

Fränger insisted that with Bosch, symbols "entail a perfect simultaneity of vision and thought" and must be treated as such. The writer considered all other approaches as "fragmentary", thus presented his study as a total view.

21. Detail of *The Garden of Earthly Delights*

22. **The Man-Tree**, ink drawing, 27.7 x 21.1 cm, Graphische Sammlung Albertina, Vienna

23. **Singers in an egg**, ink drawing, 25.7 x 17.6 cm, Staatliche Museen zu Berlin

24. **Singers in an egg**, oil on canvas, 108.5 x 126.5 cm, Musée des Beaux-Arts, Lille

In order to understand why the painter would create a mute symbolism, the art historian sorted through the whole body of paintings, separating those of enigmatic content from those that contain little or none.

Only if the "freakish riddles" on which Bosch's reputation was founded occurred in all of the paintings could they be called "the irresponsible phantasmagoria of an ecstatic". Fränger found that the deviant content existed only in a clearly defined group of altarpieces - the three large triptychs of *The Garden of Earthly Delights* (p. 26-27), the Lisbon *Temptation of Saint Anthony* (p. 52-53), and the *Hay-Wain* (p. 35). In contrast, there was only a small amount of this symbolism in such paintings as the *Epiphany* (p. 16) triptych in the Prado and the Venice *Martyrdom of Saint Julia* (p. 17). The remaining paintings, including those of the Passion and Adoration of the Magi themes, had little or none.

He concluded, therefore, that an arbitrary distinction could be made between two main groups - the generally traditional, obviously created for the church, and the non-traditional, disparate ones. Fränger concentrated on the second group, proposing that they could not have been made for a church congregation since they contained anti-clerical polemic, such as would be implied by monks and nuns depicted in disgusting attitudes. Nor could these altarpieces have been made for pagan worship, since they also attacked pagan "priests" and their ritualistic excesses.

Altarpieces, however, pointed to some kind of devotional patronage. The polar targets of their attack must have meant a group outside the Church, at once inveighing against ecclesiastical offences and at the same time fighting the abundant mystery cults of the period. The only kind of society that could possibly answer the problem, according to Fränger, would be a militant heretical sect. Setting up an ideal contrary to the teachings of the Church, such a sect would be forced to fight the all-powerful tradition, but on the other hand, would find pagan abominations equally abhorrent.

If Bosch should paint a devotional altarpiece for a society of this kind, he would mirror their "dual warfare, with all its polar tension" and his "eccentricities" would be explained. According to the scholar, all previous interpretations of Bosch approaching his symbolism without this frame of reference erred. Because Bosch was not intelligible to them, most commentators assumed that he had not intended to communicate - and that the creatures he let loose in these paintings were mere "phantoms of hell."

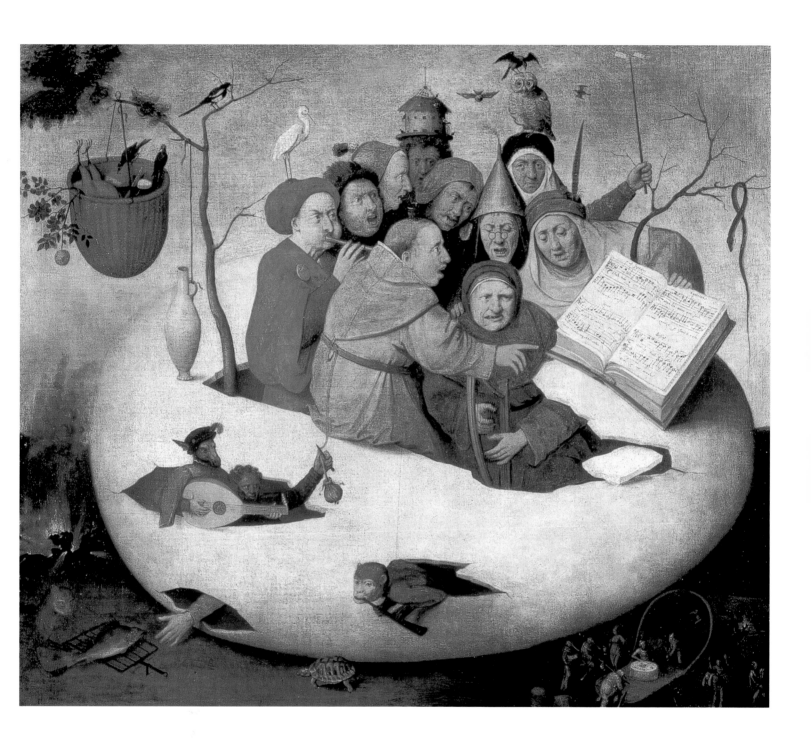

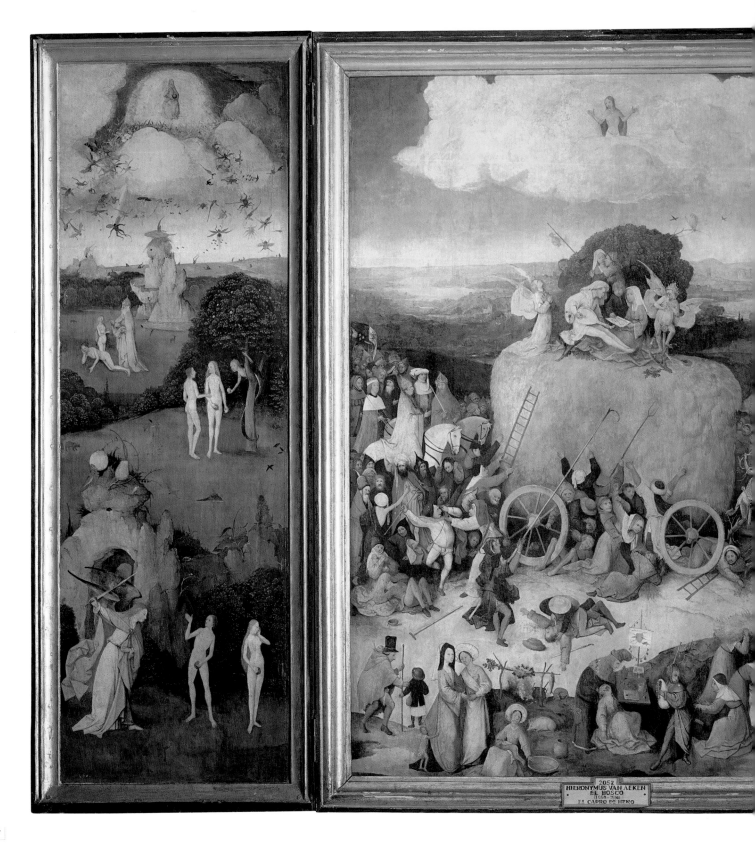

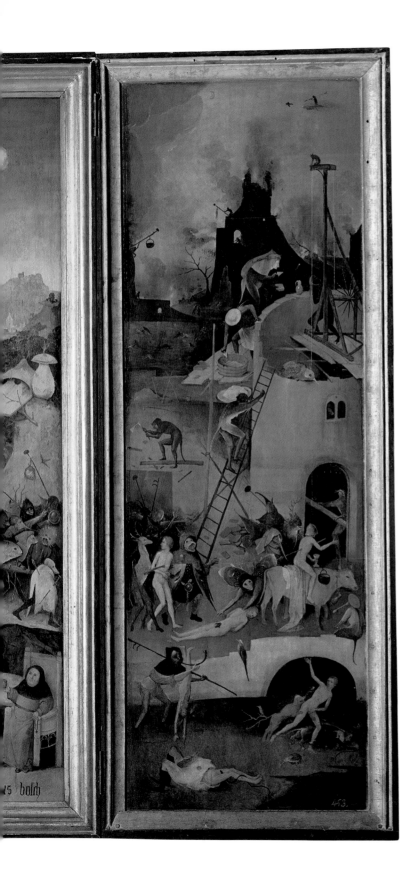

25. **The Hay-Wain**, triptych, oil on panel, 140 x 200 cm, open: left, **Eden** or **Paradise**; center, **Hay-Wain**; right, **Hell**. Prado Museum, Madrid

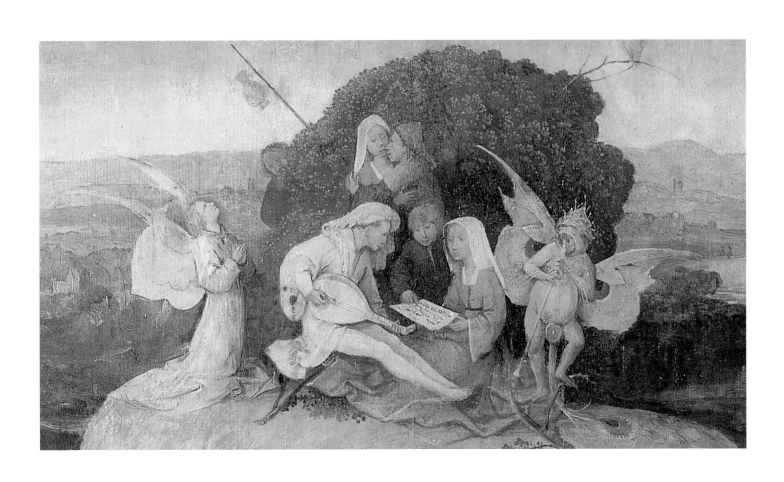

This thinking placed an emphasis on the hell scenes Bosch might not have intended. True, there are scenes which are set in the most horrific of all hells, but they are always balanced on the other side of the altarpiece by "an impeccable anchorite, or by Mount Ararat, or by the Garden of Eden."

In other words, if Bosch gave equal weight to the opposed "ideal scenes," could we not assume that he intended to emphasize these scenes by their very contrast with Hell? This added further weight to Fränger's theory of the heretical sect, because Bosch's more positive scenes would reflect the idealism of such a society.

Fränger answered his own question as to the specific nature of a cult for which these altarpieces could have been painted by reasoning that it must have been an Adamite cult.

For incontrovertible evidence of his theory Fränger offered the record of a trial in the Episcopal court at Cambrai in 1411, which charged the Carmelite friar, Willem van Hildernissen, with heresy.

This man was one of the leaders of the *Homines Intelligentiae* of Brussels, a radical branch of a religious movement active in the territory from the Rhineland to the Netherlands. Fränger inferred from certain statements in the trial record that this was the group for which Bosch produced his altarpieces.

Its members called themselves *Brothers and Sisters of the Free (or High) Spirit* in the belief that they were the incarnation of the Holy Ghost and through its power exalted to a state of spirituality that was immune from sin even in the flesh, with its subjection to lusts, so that on earth they lived in a state of paradisiacal innocence.

This is enough of Fränger's argument to illustrate the nature of his interpretation and his characteristic mode of thought - a thoroughly rational, in fact brilliantly logical analysis, which on its surface was exceedingly convincing.

Upon more careful scrutiny, however, it was the scholar's logic, not Bosch's that he revealed. What Fränger did consistently here, was to follow a system of reasoning that set up a hypothesis as an arbitrary starting point and then, through misleading inferences, arrived at subsequent hypotheses and developed the conclusions implicit in them, *ad infinitum*.

26. Detail of the central scene of **The Hay-Wain**: the hay wagon with the lovers on top of it sur-rounded by a blue trou-badour and an angel

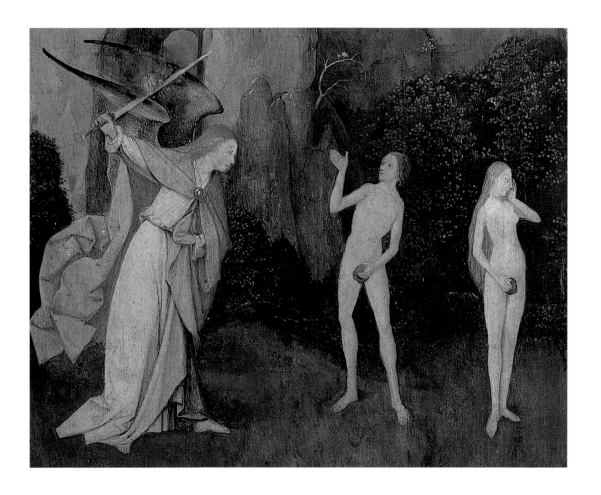

A thought construction was created, no part of which could be removed without damage to the whole, nor explained without reference to the whole. But the entire structure rested upon the original hypothesis, a very shaky foundation indeed.

This was Fränger's hypothesis: that the paintings containing the major part of Bosch's enigmatic symbolism, being in the form of altarpieces, must have been made for a devotional purpose.

They contain anticlerical and anti-pagan invective that could have been made neither for the Church nor for a pagan group. Since it was not the practice of a late medieval artist to paint merely for his own satisfaction, nor is it conceivable that private commissioners would have wanted such odd altarpieces for their own chapels, there

must thus have been a group outside the Church, operating between its severe discipline and pagan anarchy, but fighting both. These paintings must have been made for a heretical sect, therefore, which was forced to hide its ideas in secret symbols, whose explanations would clarify Bosch's enigmatic figures.

To Fränger, this meant no doubt the Adamite cult. Are the points of the hypothesis defensible? The traditional altarpiece form strongly implied a devotional purpose to the historian - therefore, he had to seek the type of group which would use Bosch's altarpieces for such a purpose.

It is not absolutely necessary, however, to think of these paintings as having a devotional purpose. This was not a time of strict adherence to tradition. Northern Europe was at the end of the fifteenth and the beginning of the sixteenth century in a period of great transition.

Already, the influence of the Renaissance from the South had been felt, entailing a discard of many old forms and ways. There was a growing secularization, resulting in a patronage for artists widened far beyond the extent of the Church.

It is conceivable that the altarpiece form could have been used for a non-devotional painting commissioned by a private patron - merely because it allowed for intriguing complexity. The artist's popular appeal is shown by the fact that his manner and subject treatments were adopted so quickly by artists.such as Huys and Brueghel. It may be that Bosch painted for a delighted audience, only too happy to keep him in commissions.

We know from records quoted above that he was held in great repute by his fellow townsmen. We know, too, that both the Emperor Charles V and one of his courtiers, Felipe de Guevara, had acquired several of Bosch's paintings within a remarkably short time after the painter's death.

The fact that Charles' son Philip confiscated one altarpiece from a rebellious Netherlandish Burgher makes it seem more likely that some paintings were owned privately rather than being part of the sacred equipment of churches; but it suggests as even less likely that the paintings were the hidden and guarded property of heretical sects.

27. Detail of the left panel of *The Hay-Wain: Eden:* Adam and Eve leaving Paradise

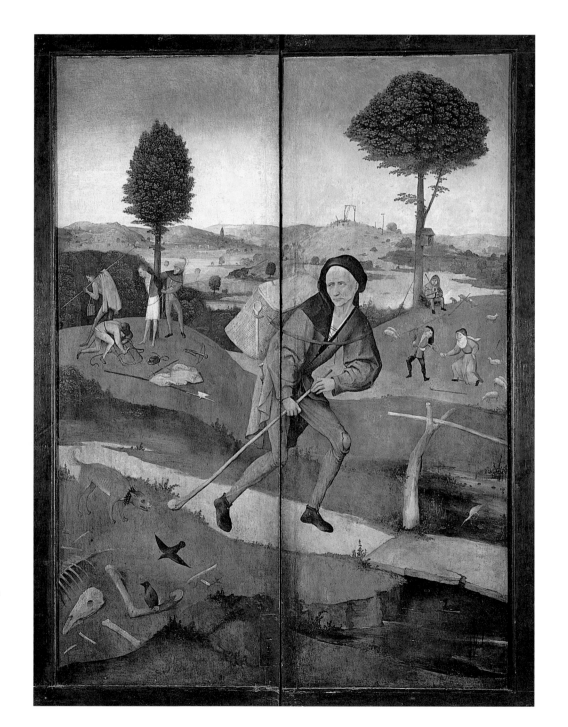

28. Exterior view of **The Hay-Wain,** triptych, oil on panel, 140 x 200 cm, Prado Museum, Madrid

29. **John the Baptist,** wing of the Altarpiece from the Brotherhood of Our Lady, oil on panel, 48.5 x 40 cm, Lazáro Galdiano Museum, Madrid

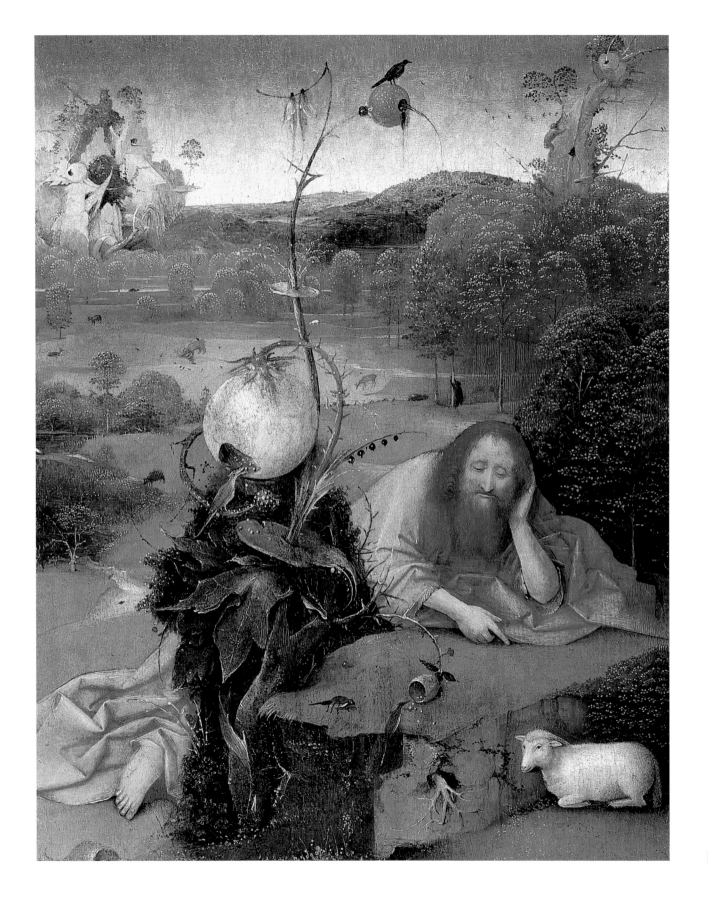

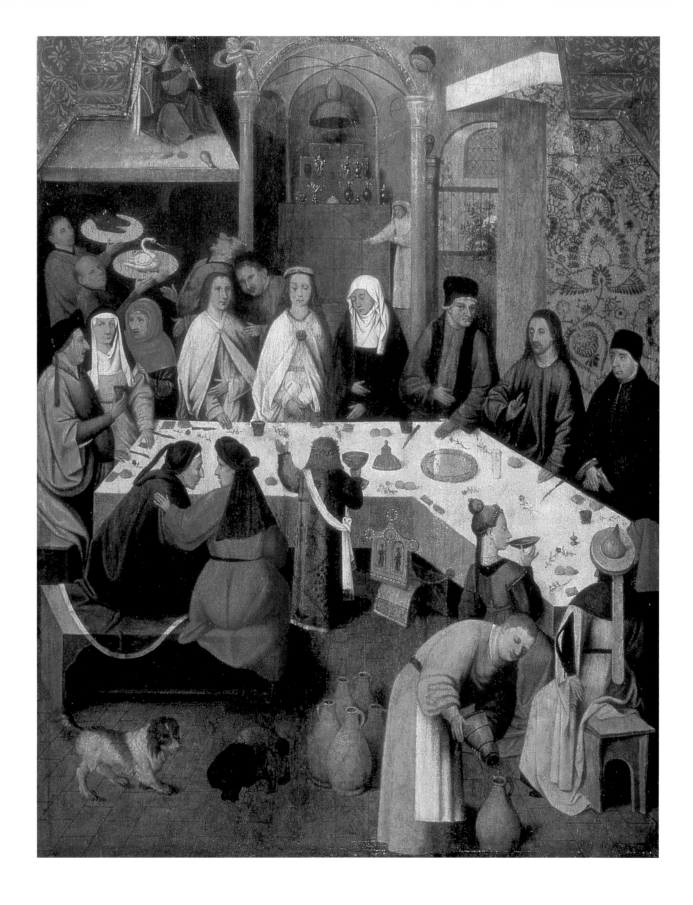

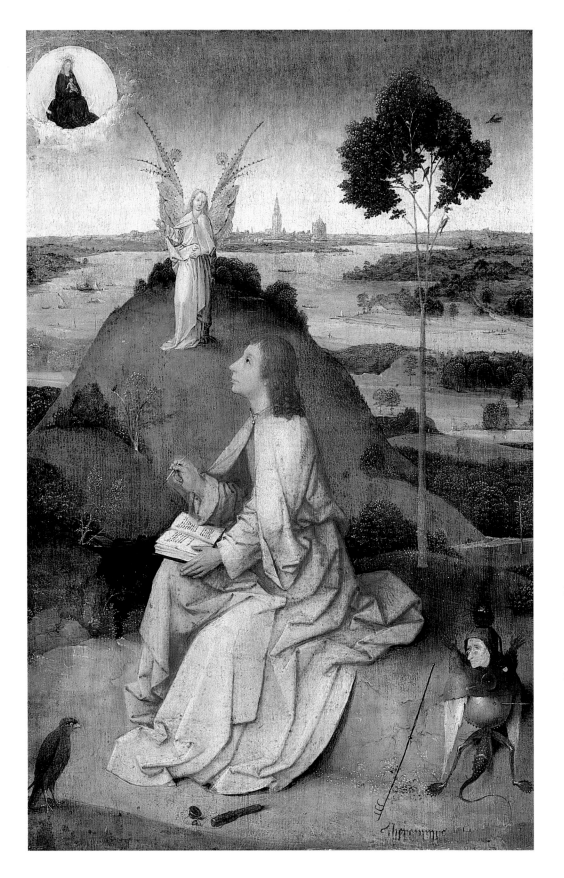

30. ***The Marriage at Cana,***
c. 1561 or later. Oil on
panel, 93 x 72 cm,
Museum Boymans Van
Beuningen, Rotterdam

31. ***Saint John on Patmos***,
wing of the Altarpiece
from the Brotherhood of
Our Lady, oil on panel,
48.2 x 34.5 x 17 cm,
Illustre Lieve-Vrouwe-
Broederschap, 's
Hertogenbosch

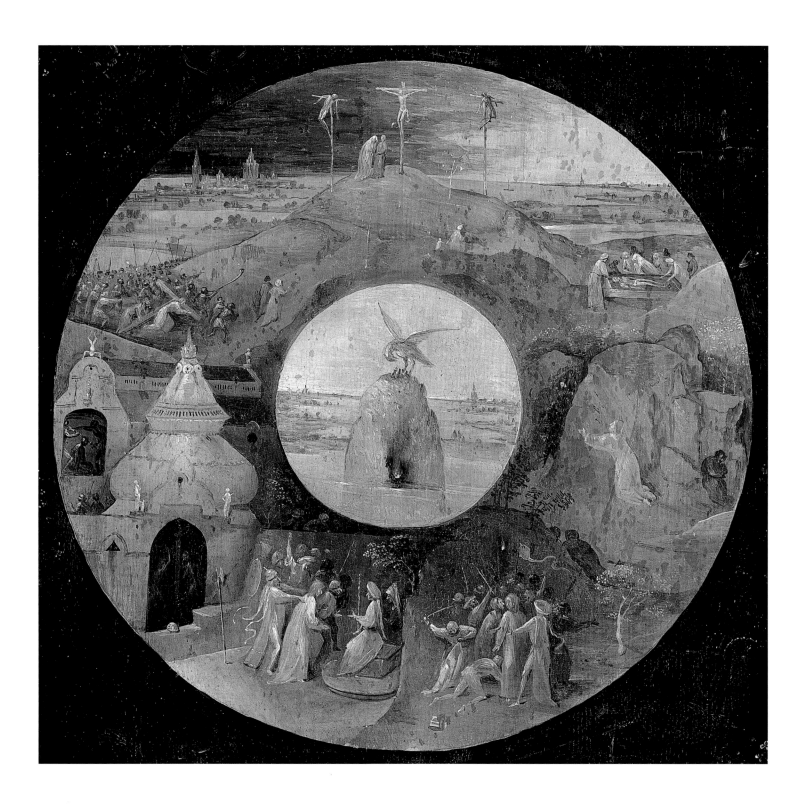

If such were the case, it is improbable that the paintings would have been in free circulation at such an early time after the artist's death. Fränger's system of reasoning is so tightly constructed, with so little possibility of error that he seems to assume that his audience would inevitably reach the same conclusions.

One example will suffice to show to what fantastic excesses such thinking can and does lead in his interpretation. Fränger had previously demonstrated in his analysis of the central panel of *The Garden of Earthly Delights* (p. 26-27) that this fabulous display of erotic activity was in celebration of an actual marriage event.

Therefore, he assumed that this also became the occasion for a pictorial revelation of the "society's" mysteries - including all of the levels of knowledge a member could attain by instruction and by which he could finally reach full initiation into the group.

Since it is such a "unique pictorial creation, in which the whole universe has been assembled to sing praises such as no king and queen ever heard on their wedding-day," it must be a truly "god-like couple," which is being married, Fränger proclaimed and went on to find them in the lower right corner of the panel, half-hidden in a cave.

The man is the only clothed figure among the abounding nude ones, he said, and proposed further differentiations as well. A man who exalts himself by such self-awareness as this one, and who is further being exalted by such a wedding celebration, could be one of only two people to Fränger - either the painter Bosch or the man who inspired the triptych.

Since this is not a portrait of Bosch, it must according to the writer be the face of the "man who commissioned such an extraordinary work of art and inspired its intellectual conception, [and] we can go even further and make the conjecture that this portrayal of the bridegroom is also that of the Grand Master of the Free Spirit, who meets us with a piercing, scrutinizing gaze on the threshold of his paradisiacal world."

Having so thoroughly convinced himself of his assertions, Fränger introduced the elusive "Grand Master" into "early Dutch social and art history [as] a powerful spiritual personality, hitherto completely unknown, one who is worthy to rank with those three great men of the same country and the same century, Erasmus Desiderius of Rotterdam, Johannes Secundus, and Johannes Baptist van Helmont."

32. Exterior view of *Saint John on Patmos,* wing of the Altarpiece from the Brotherhood of Our Lady, oil on panel, 48.2 x 34.5 x 17 cm.

Thus, Fränger not only endowed his invention with physical aspect, personality, bride, and philosophy, but he bestowed on him greatness. In the process, he destroyed Bosch not only as a personality, but also as an artist. It was not long before the Grand Master ceased to be elusive, because Fränger claimed, in his article on Bosch's *St. John of Patmos*, published in 1949-1950, to have discovered the man's identity. He had learned that a Jewish resident of 's Hertogenbosch, named Jacob van Almaengien, was baptized ceremoniously in the presence of Philip the Fair of Brabant.

Nothing but circumstantial evidence in the official records connected this man with the artist, but he was listed as having been registered as a member of the *Brotherhood of Our Lady* for the year 1496-1497, under the Christian name Philip van Sint Jan. Of course, Bosch had been a member of the order since 1486.

This was not proof enough to convince many Boschian historians, especially the Dutch ones, such as Dirk Bax, yet the evidence was so compellingly argued by Fränger that to Patrik Reuterswürd and others it seemed highly suggestive.

Fränger is good reading, everyone agrees, but most historians do not agree that his creation is more than a fabrication of his own imagination. Many very reputable historians tackled the enigma of Hieronymus Bosch both before and after Fränger died in 1964. Writing still in the late 1950s, soon after Fränger discharged his first salvo, several historians began to stress the more serious, possibly even conventional appeal of Bosch's paintings: Max Friedländer sounded the general view that the artist's contemporaries "considered them as sermons with a moral." Charles Cuttler averred that "Bosch's unnatural yet natural beings, pieced together with artistic rather than natural logic, were a perfect vehicle for his serious, moralizing exaltation of basic Christian ideals...."

In 1959, Ludwig von Baldass identified several of the artist's patrons as being eminently respectable: Philip the Fair of Brabant and his sister the Archduchess Margaret, William of Orange and the Archduke Ernest, as well as more common (but undoubtedly affluent) citizens of Amsterdam, Haarlem, and Antwerp - including Rubens in the 17th century. Baldass also mentioned Bosch's influences among his great Flemish forebears (assuming that he did not know those from Ghent - mainly Eyck or Goes) as Weyden, Bouts, Geertgen, and Memling, as well as several International Style artists (through a vignette from Italy, perhaps?).

33. *Ascent of the Blessed to the Heavenly Paradise,* oil on panel, the second of four panels in the triptych entitled *Visions of the Hereafter,* each 87 x 40 cm, Ducal Palace, Venice

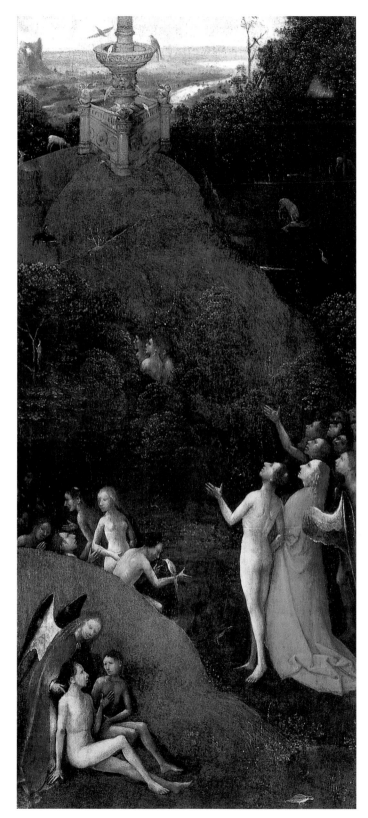

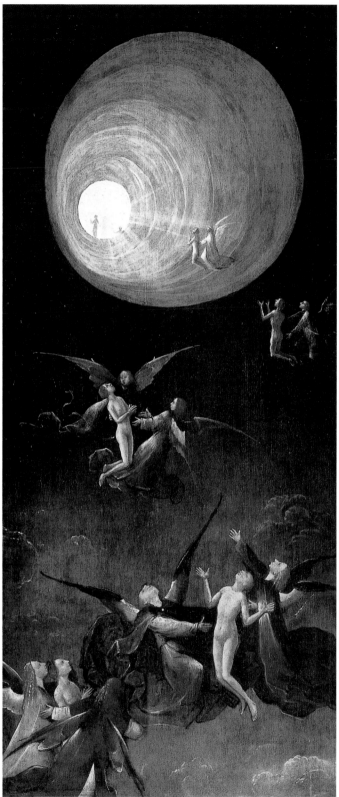

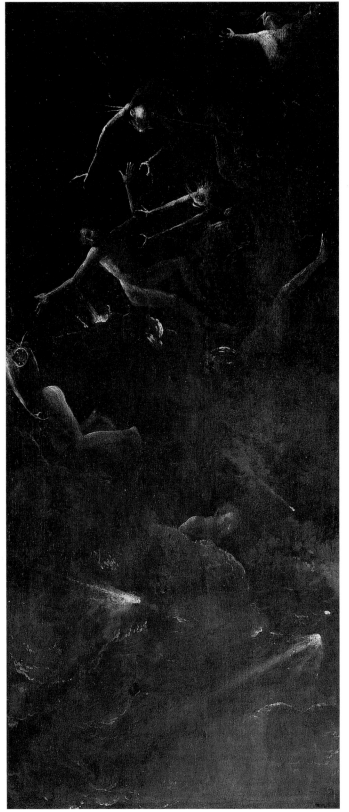

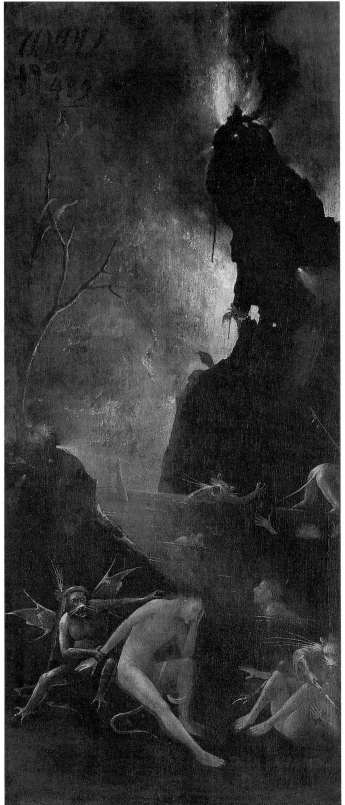

He thought the artist was the first in Flanders and Holland to understand the importance of drawing for planning and clarifying details. In addition, Baldass saw Bosch as a consummate inventor, never drawing only what he saw or taking from other artists. Among the striking recent studies have been those of Laurinda Dixon.

She built upon the alchemical interpretation of Bosch's work, but sought a middle ground between what she considered their too disparate approaches. She found this in the more mundane field of pharmacy. Not only had there been a pharmacist in Bosch's wife's family, but Dixon believed that the artist's middle-class background would have drawn him more to the practical craft of pharmacy, which was associated with both alchemy and medicine, but was much less esoteric than those.

Bernard Vermet added new information to the dating of the artist's paintings, primarily from the standpoint of "dendrochronological" testing (of growth rings of the wooden panels on which they were painted) done by contemporary scientists.

Among the controversial findings that he and Koldeweij contributed, or reported, was that *The Marriage at Cana* (p. 42) was produced at least a half-century after the artist's death. As an example of a talented follower, Vermet related that the Spaniard Felipe de Guevara wrote around 1560 of a highly accomplished pupil of Bosch's, who could outdo his master in imitating him and signing works in his name, and that frequent retouching of Bosch's paintings after his death made technical comparisons very problematic.

This historian made a thorough survey of the remainder of Bosch's paintings, detailing the new proposals on the dating or authenticity of the artist's work. Paul Vandenbroeck showed how Bosch used Christ and angels to balance the negative in his work.

Christ might seem to despair when he displays his wounds to the sinful mass below, but by so doing, "he draws attention to his suffering, through which he will save the humanity that has forgotten its God". The author concluded that Bosch was deeply imbedded in the urban, bourgeois culture that surrounded him, but became wealthy enough by his work to separate himself from the "artistic norms of his time".

The artist had summed up his independence by appending a Latin quotation (possibly from Boethius) to one of his drawings: "It is characteristic of the most dismal of minds always to use clichés and never their own inventions."

34. *Ascent of the Blessed to the Heavenly Paradise*, oil on panel, of the triptych entitled *Visions of the Hereafter*, each 87 x 40 cm, Ducal Palace, Venice

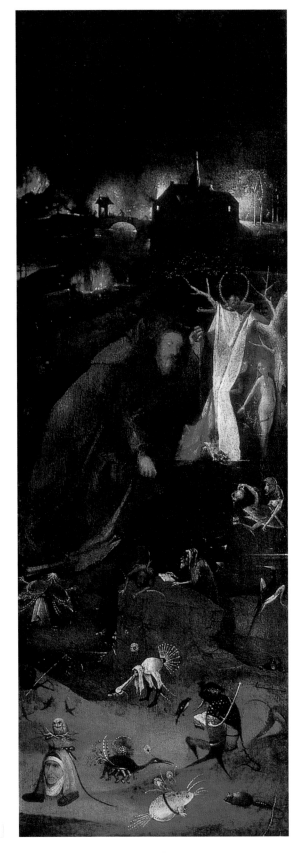

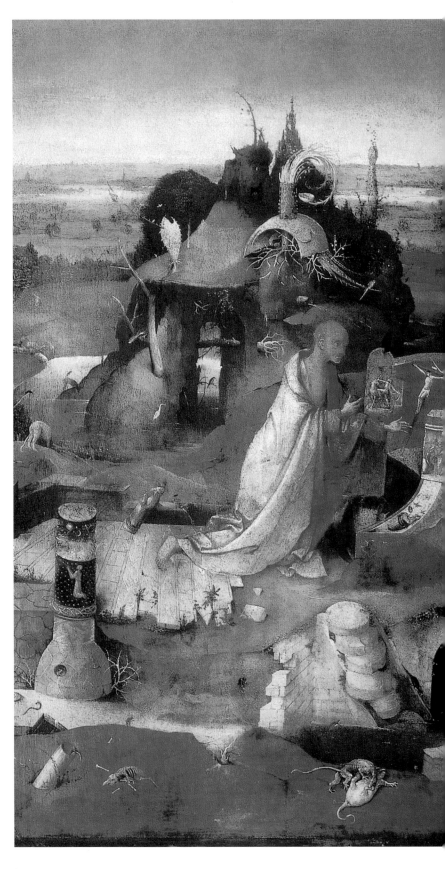

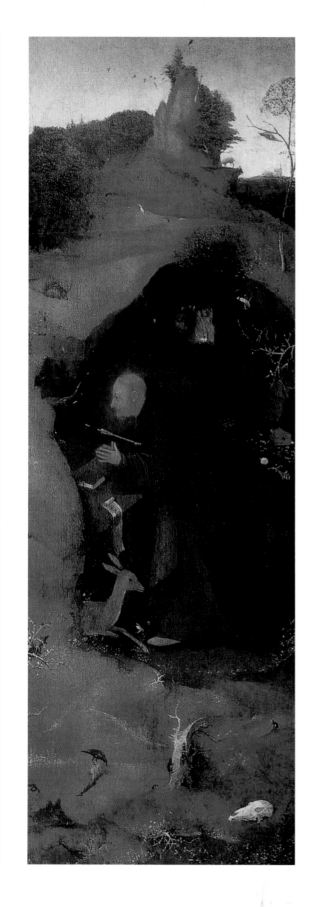

35. *Hermit Saints Triptych,*
oil on panel,
86.5 x 60 cm, Ducal
Palace, Venice

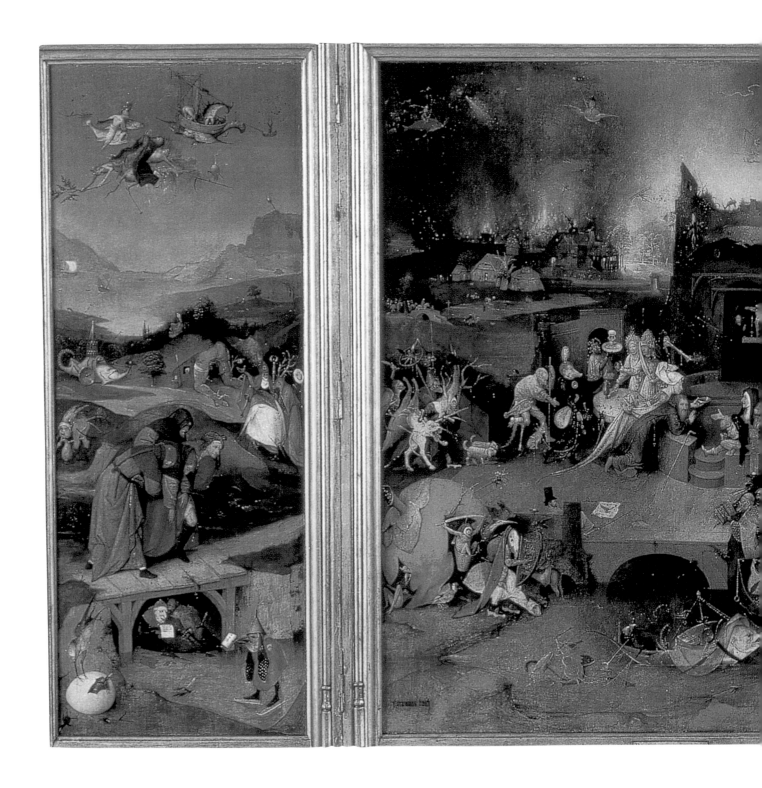

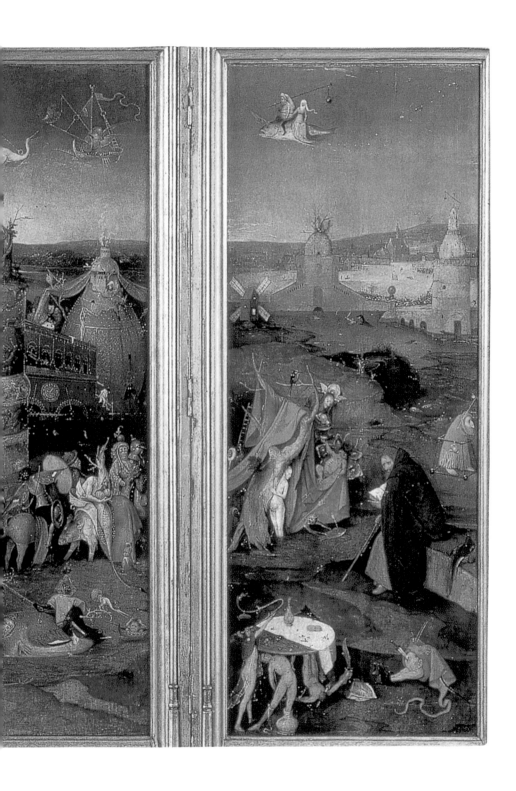

36. ***The Temptation of Saint
 Anthony,*** oil on panel,
 131 x 119 cm, National
 Museum of Fine Arts,
 Lisbon

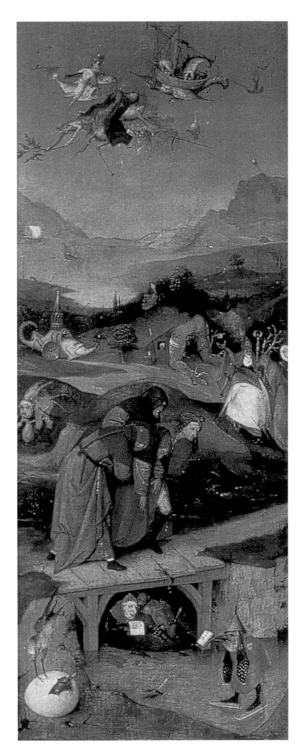

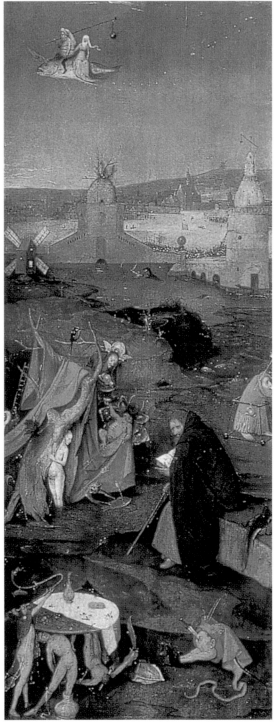

37. ***The Temptation of Saint Anthony,*** left panel

38. ***The Temptation of Saint Anthony,*** right panel

39. Exterior view of ***The Temptation of Saint Anthony,*** oil on panel, 131 x 119 cm, National Museum of Fine Arts, Lisbon. Left exterior panel, ***The Arrest of Christ***. Right exterior panel, ***Christ Carrying the Cross***

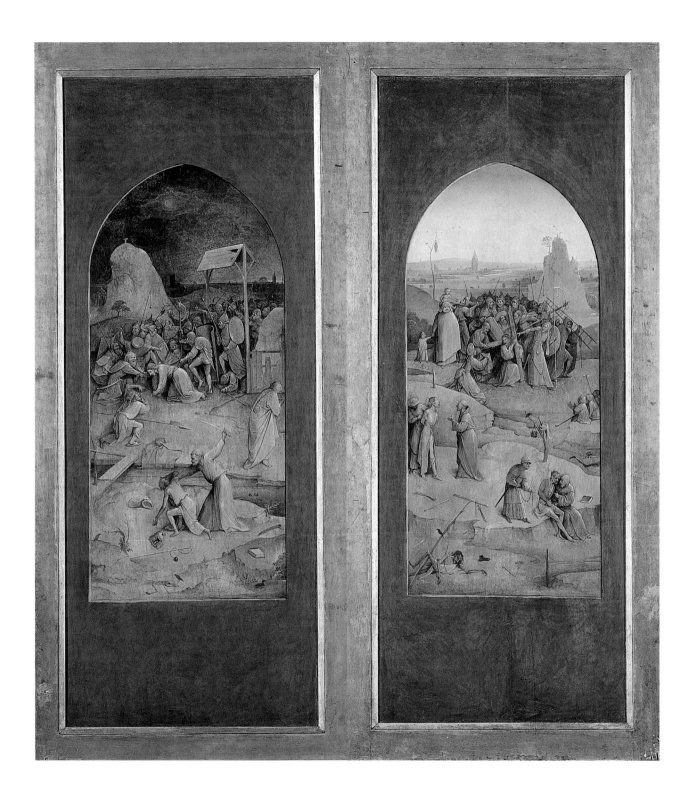

Before reestablishing Bosch's position as an artist by discussing his "mode of visual thought" as the process by which he created his marvelous imagery, we shall consider the conditioning influences that must have directed his use of an unusual formula. This is because no artist, not even a unique one, develops autonomously.

The growth of an artist like Bosch is the result of a combination of unusual circumstances influential in his background. Hieronymus Bosch was certainly not closely allied to any school or group of artists. As a result, he did not follow the artist's usual pattern of seeking to advance technical knowledge for its own sake, even within the framework of religious subject matter. Although he developed into a first-rate technician, it is nevertheless apparent that his technical achievements evolved from the demands of religious necessity. He was, undoubtedly, intensely religious.

His paintings exude belief of an extraordinary nature. The fact that his governing drive was the desire to heighten religious experience would be a prime factor in his freedom from the ordinary artistic restrictions. His lack of preoccupation with reality has made him incomprehensible to the layman and historian alike, but this would naturally follow from his desire to concretize such imaginary concepts as Heaven, or Hell, or the visions of a saint. His technical facility with such difficult passages as the cloud-formed tunnel to Heaven, or the fire-lit night sky of Hell would be the result of his wish to intensify the revelatory impact of these concepts.

There were many other factors at work in the formation of Bosch's artistic *modus*. De Tolnay made the point that the artist's very originality in technique and ideation may have resulted from his physical isolation from the main artistic currents of his time. There is no record of his ever having traveled outside his hometown. If he had never seen the paintings of the great Flemish masters, his most immediate influences would be those found in a provincial town. The content of his paintings seems much closer to popular sources, such as illumination and incunabula, than to that of the Flemings.

Although he worked in oil paint as they did, he did not employ their elaborate glazing method and, perhaps, had no knowledge of it. His was an *alla prima* technique, which some people believe to be his application to oils of a fresco painting manner, conceivably resulting from his admiration for the frescoes in the cathedral of 's Hertogenbosch.

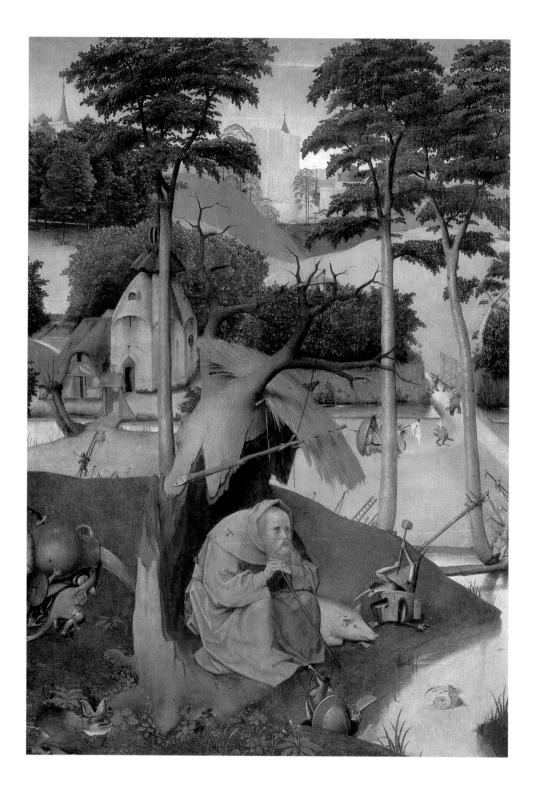

40. ***The (little) Temptation of Saint Anthony***, 73 x 52.5 cm, Prado National Museum, Madrid

41. ***The Temptation of Saint Anthony***, ink drawing, 25.7 x 17.6 cm, Staatliche Museen zu Berlin, Kupferstichkabinett, Berlin

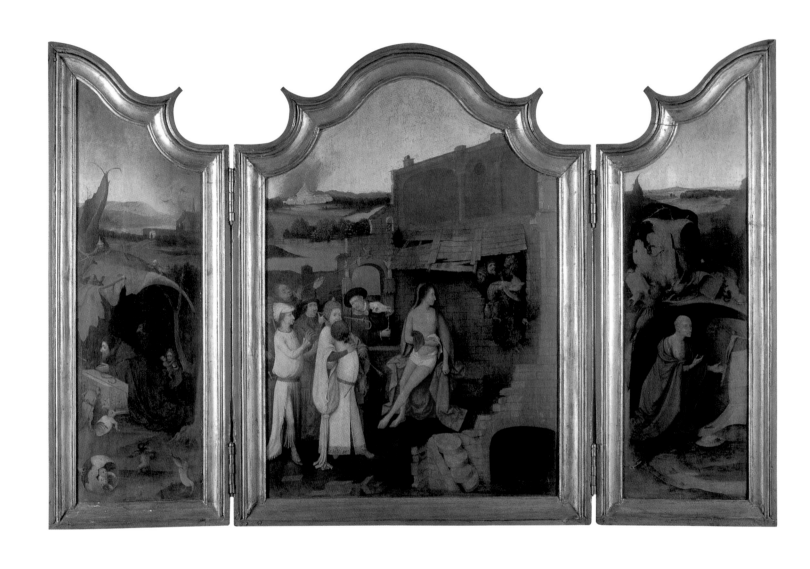

42. *The Hardships of Job,*
98 x 72/30 cm, Groenige
Museum, Bruges

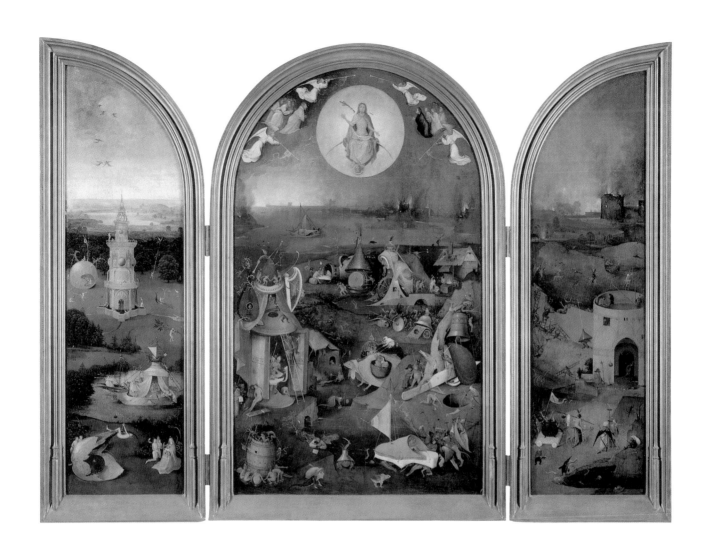

43. *The Last Judgment,*
Groenige Museum,
Bruges

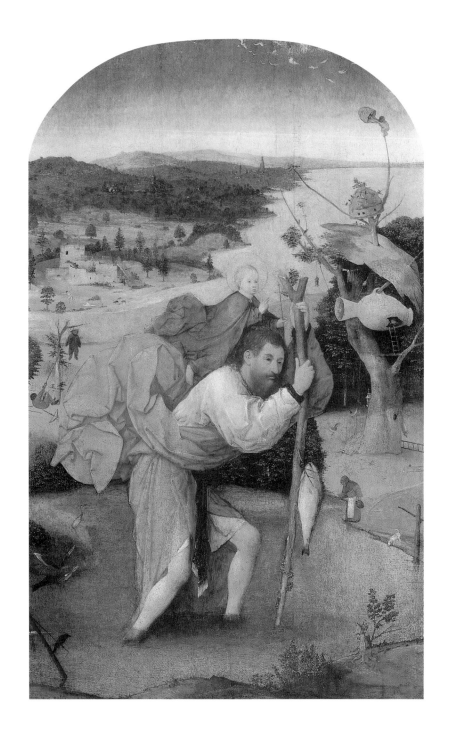

44. *Saint Christopher,*
113 x 71.5 cm, Museum
Boymans van
Beuningen, Rotterdam

45. Exterior view of *The Hardships of Job*, Groenige Museum, Bruges

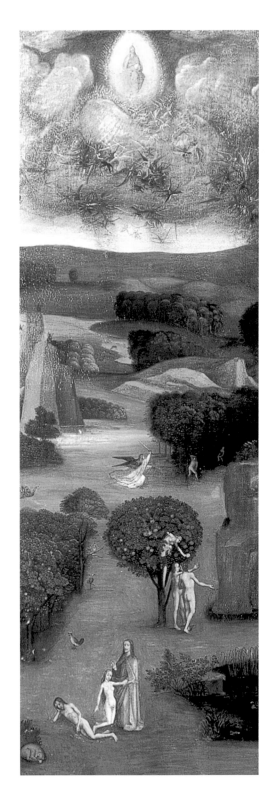

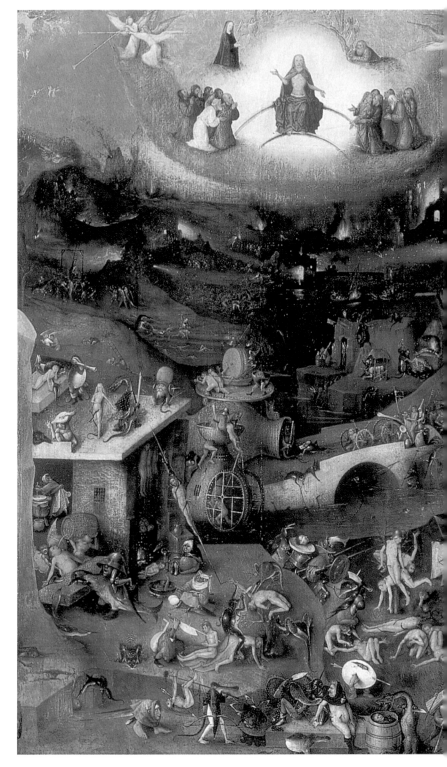

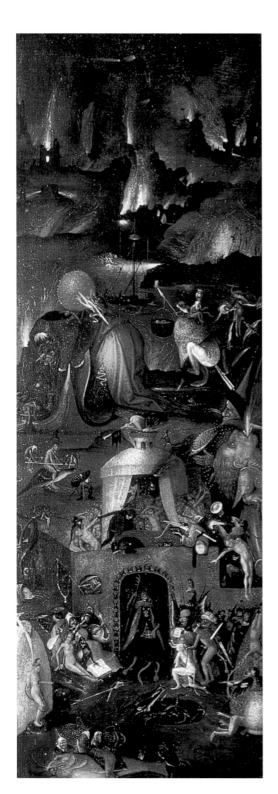

46. *The Last Judgment,*
 c. 1482.
 163.7 x 127/247 cm,
 Gemäldegalerie der
 Akademie der bildenden
 Künste, Vienna

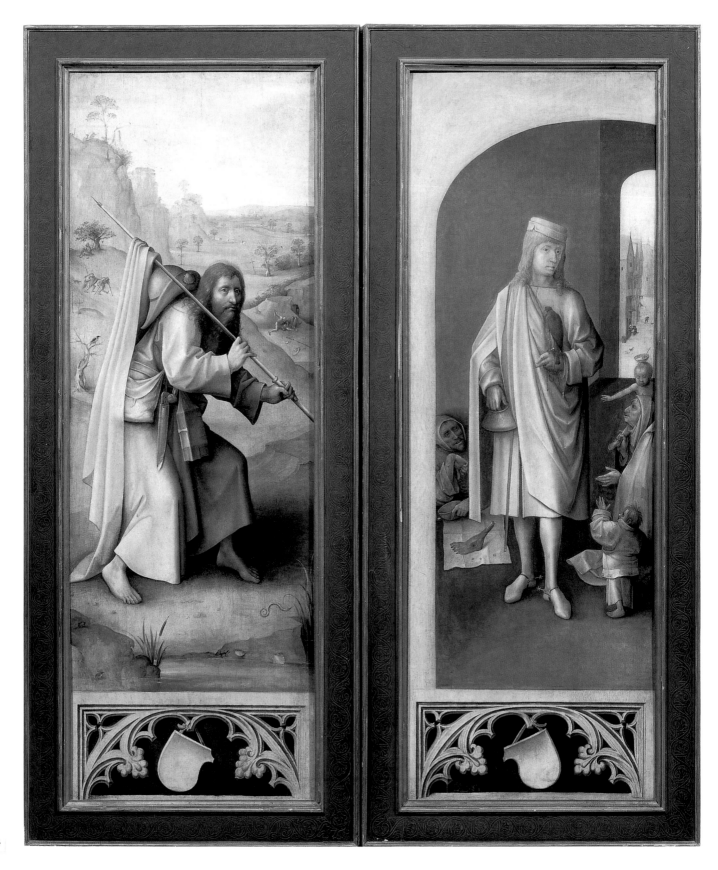

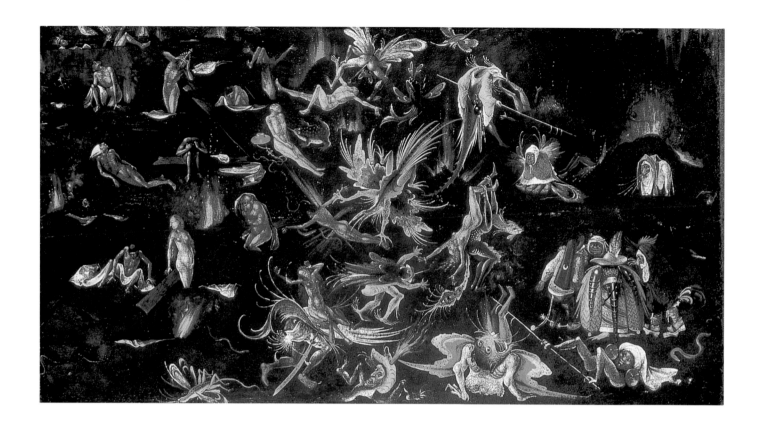

Their "International Style" figure treatment may explain the archaism of the figures in his early paintings. An artist is never completely isolated from larger artistic heritages, however. Ideas are "in the air" and are bound to have their penetrative effect. He had a certain identity with Dutch art of his period. According to historian Otto Benesch: "Dutch art of the late fifteenth century, in spite of its tremendous height of pictorial mastership, had as its chief aim not perfection of craftsmanship and naturalistic observation of the Flemings, but expression.

The same subjective religious spirit which brought about the mystical movements of the *Brothers of the Common Life* [the Ruysbroek followers] ... fills the works of the Dutch painters, whether they go in a realistic direction, like Geertgen tot Sint Jans, or in a fantastic and visionary one, like Bosch." Benesch called this direction "Dutch Flamboyant Gothic," but it was part of a movement of wider dispersion than this name would indicate. De Tolnay pointed out that there was a Neo-Gothic current spreading throughout Europe during the last quarter of the fifteenth century, appearing "simultaneously at Florence with Botticelli and Filippino Lippi, at Venice with Crivelli and Vivarini, in Germany with Schongauer, in Flanders itself with Juste de Gand."

47. Exterior view of *The Last Judgment*, c. 1482, 163.7 x 127/247 cm, Gemäldegalerie der Akademie der bildenden Künste, Vienna

48. Fragment of *The Last Judgment,* 60 x 114 cm, Alte Pinakothek, Munich

49. ***Two Monsters***, ink drawing, 8.6 x 18.2 cm, Staatliche Museen zu Berlin

Bosch's involvement with Gothic art may have been more personal, however, than as a result of a generalized trend. The Cathedral of Saint John in 's Hertogenbosch is called one of the finest examples of French Gothic architecture in the Netherlands. It is known, as shown in records cited earlier, of Bosch's close association with the cathedral by virtue of his artistic contributions to its decoration.

The cathedral had burned in the early part of the century and the repairs were still in progress in the painter's youth. He probably grew up watching the wood and stone carvers at work in the churchyard.

The most obvious result of such an observation was his love of the chimeras and grotesqueries that enjoy self-sufficient life in his works. A more important contribution of Gothic art to Bosch, however, lay in its mode of expression. Since the laws of Gothic

art are determined by its own dynamics - not by the necessity of an adherence to nature's laws, its influence allowed the artist his initial freedom from nature. Some historians have believed that Bosch was not at all influenced by the great achievements of the fifteenth century, but was a complete reversion to Gothic, or International Style, or pre-Eyckien "archaism."

It was not possible for Bosch to have remained untouched by the artistic achievements of his own century. He was a master of illusionistic spatial recession, often applied more vertically than perpendicularly, but not achieved to such a degree in any previous century. He could indicate ephemeral effects, such as a smoke filled sky, with startling effectiveness. Though not a naturalist in the sense of insisting on surface detail, a prime delight of the Flemings, he could differentiate textural substances.

50. *Man without body and one monster,* ink drawing, 8.6 x 18.2 cm

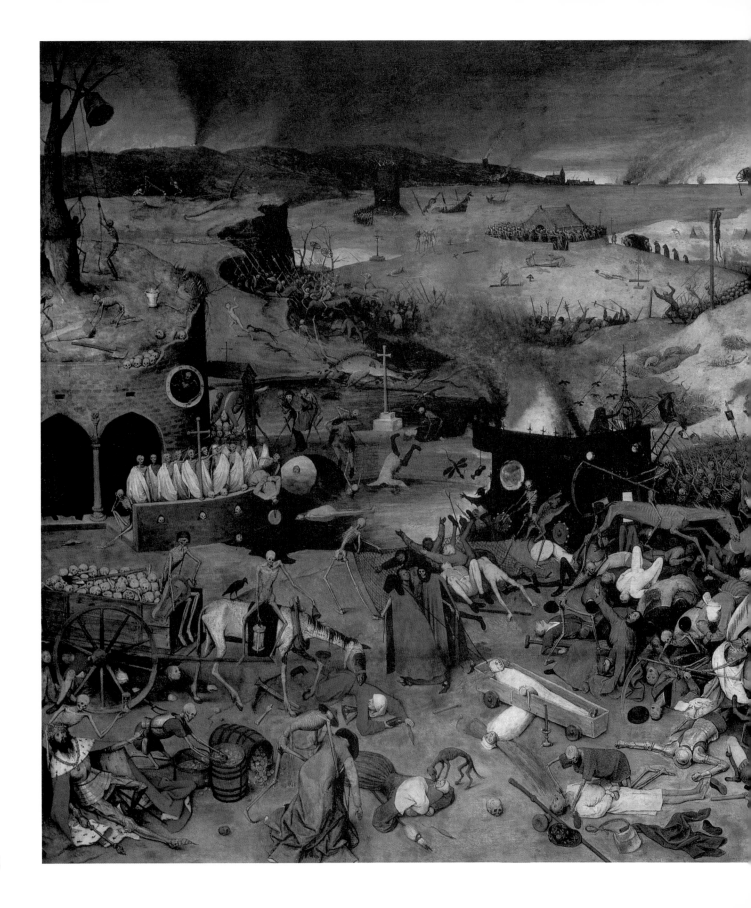

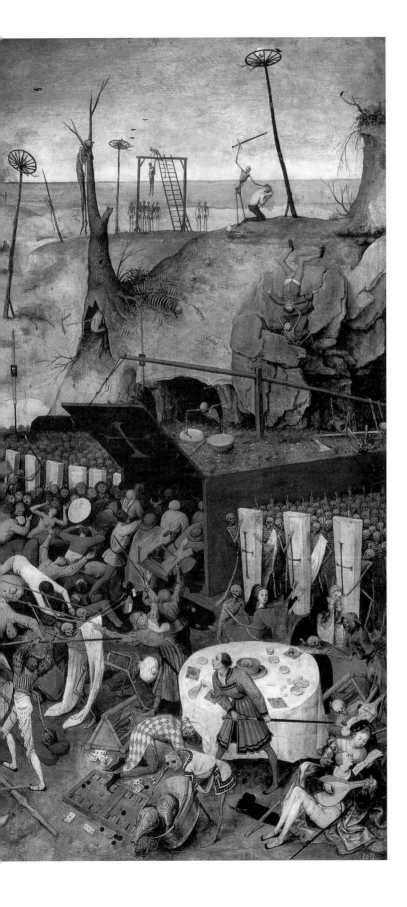

51. Pieter Brueghel the Old (1528 - 1569): **_The Triumph of Death,_** oil on panel, Prado Museum, Madrid

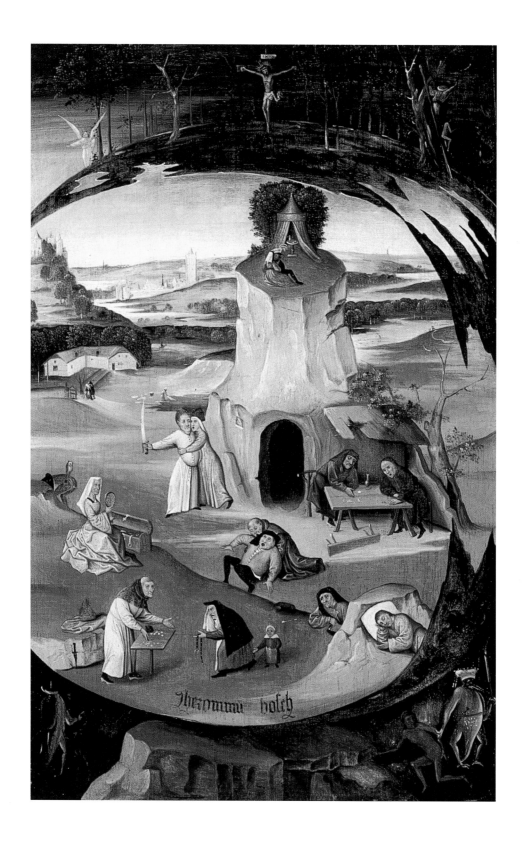

It has been emphasized that, from his Gothic influence, he would have felt it unnecessary to render the world's logical aspect and could so deal freely in imaginative realms. It was just the skill that he possessed of rendering some natural effects, and which he used in the service of his imagination, that produced his peculiar identity.

To be more inclusive, it was the combination of his knowledge of fifteenth-century achievements, Gothic ideation, his sectional and local provincial background, and his personal qualities of religiosity and imagination - all of which would contribute to the formation of this completely unique artistic personality.

The irrational element in Bosch's paintings, one of the results of his distinctive motivations, is not a unique phenomenon in art. If the whole sweep of art history is considered, there have been many artists violating logic in their subject treatment, but until the past century they have not existed in sufficient number at any one time to form a school.

The manner in which they worked is consistent with a true understanding of the artistic process. We wonder that there have been so few of these artists, but when one realizes the fate of Bosch in general opinion, the reason is apparent.

The fact is that few people are objective enough to separate the image from reality. This inability causes the lay observer to expect the image to retain the aspect of its counterpart in life and to assume, if it does not, that this disparity reflects an unbalanced mind.

It would be presumptuous to claim to understand the mind of Hieronymus Bosch, and therefore, the exact nature of his "mode of visual thought." It would be impossible to tell whether he worked according to rational or irrational directives. His imagery is so involved that many processes may have been operative in its formation. In part, Bosch was undoubtedly illustrating in a rational manner ideas received from theology and folklore.

His hybridization was a flamboyant elaboration of the same device used so often by medieval artists. The strange effects he achieved would be partially explainable by his reasonable desire to present the obverse satanic world, by "queering" the normal one.

52. *The seven deadly Sins in a Peel of terrestrial Globe,* oil on panel, 86 x 56 cm, Fine Arts Foundation, Geneva

He would make his creatures, their activities, and their environments as weird and unworldly as possible, yet, the painter would make these things believable by rendering them with all of the technical mastery an artist would ordinarily use to produce the illusion of the natural world.

That Bosch was also acting according to subconscious directives within the framework of his rational intentions cannot be doubted. His paintings are compelling in their power on the viewer.

Of course, it may be that this fascination on the viewer's part is the result of the stimulation of *his* or *her* subconscious mind by Bosch's imagery. The explanations that the viewer attempts to read into the imagery may not have existed in Bosch's mind at all.

But psychologists believe that the subconscious mind is much alike in every person; so, what Bosch produced by allowing his subconscious mind its play might evoke a deep response by recognition of something with which the viewer also held subconscious familiarity.

Hieronymus Bosch's difference was that he did not confine himself to the traditional reference. He used the method by which the common symbols had been made - evolving as they did from countless origins, formed by free association of ideas in many minds, accepted into common usage if they had universal impact.

The painter simply made his own associations, but the images which he created are not to be looked upon as having objective meaning that can be disassociated from the visual creation.

Whatever the means employed by the artist to achieve effects and whether they were fully intentional or not, it is certain that he did intend to convey the impression of evil. In fact, it should always be kept in mind that this was the painter's central motive.

53. *Ecce Homo,*
71.1 x 60.5 cm,
Städelsches
Kunstinstitut, Frankfurt

The desire to record the pervasiveness of evil in the world and in its many guises was such an extraordinarily religious motivation with Bosch that it gives direction when there seems to be none. It offers control when control seems forgotten.

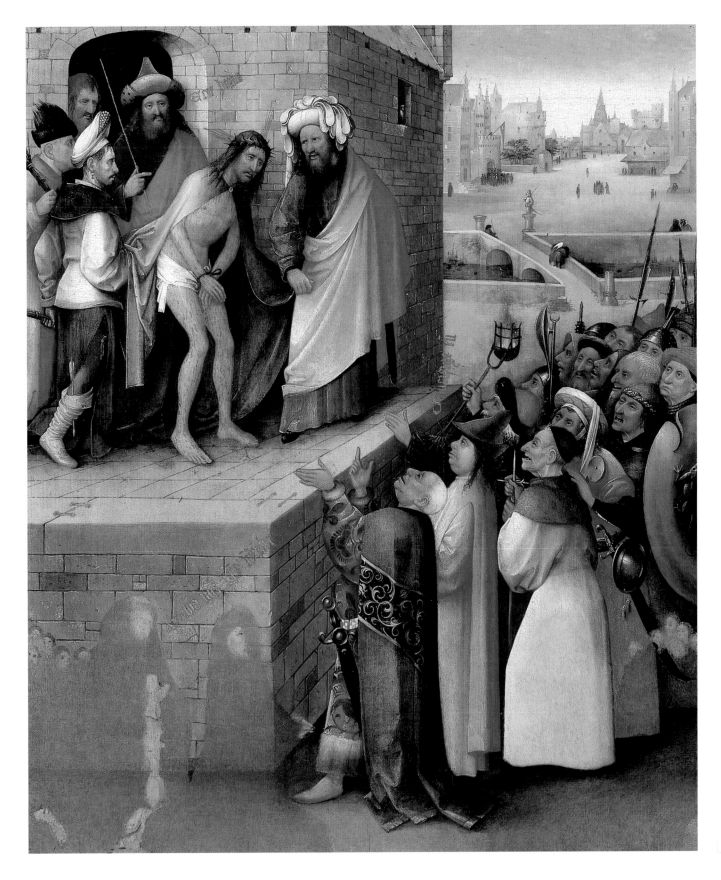

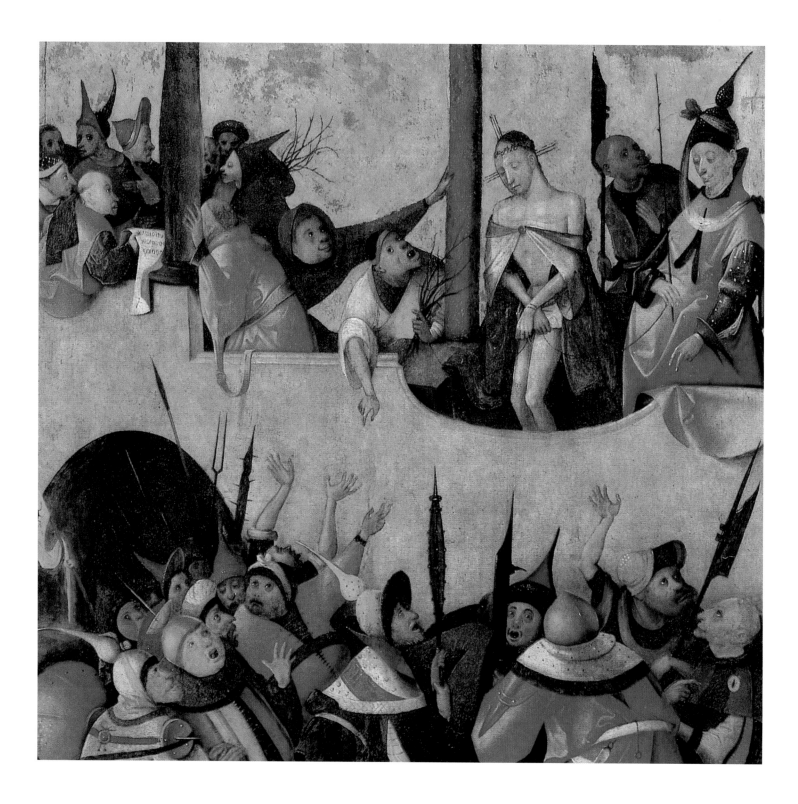

It was with full awareness of this purpose that Bosch created an orderly arrangement in which the agents of evil swarm in profusion and confusion.

Holding the control of awareness over the whole the artist relaxed it in the parts. It is only when an attempt is made to analyze the parts, that the basic order is forgotten and chaos seems to reign.

The baffled viewer then decides that Bosch was either a mad projectionist of his uncontrolled hallucinations or else that he hid his rational meaning in a labyrinth of symbolism to which someday, someone will find the map.

There can be no rational interpretation of these paintings. Nor does this mean that Hieronymus Bosch was mad. With a fully rational mind this artist set his stage; then, (to adopt an anachronistic figure of speech) he placed his mind "in neutral" and allowed it to be propelled by his imagination.

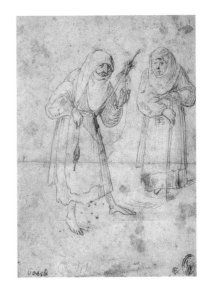

In other words, he surrendered his consciousness to his unconscious mind. Whatever restraints there are that work the mind in related, reasonable, patterns were dropped. The images of the human mind - that come and go - and not searched out or kept in order - from which no ideas are abstracted - among which no selection is practiced - were allowed a concatenation of their own making.

From knowledge implanted at earlier times - at many times, these images were churned up from obscure levels in the artist's mind.

Similarly, the images formed in many systems made to explain evil came to the artist's mind in an incredible number of combinations, thus accounting for the variety of usages over the panels.

In musical terms, the result would be as the "music" played by the wind on an aeolian harp. It can be argued that such noise is chaotic, but the strings are tuned in unison. In the same way, the artist's mind was tuned to his subject.

He knew for what (the service of the Lord) and against what (the machinations of the Devil) he allowed his mind to play. There is, indeed, obscurity in the utterances of this man, and it would not be argued here that the obscure is necessarily profound.

54. *Ecce Homo,* oil on panel, 52 x 53.9 cm, Philadelphia Museum of Fine Arts, Philadelphia

55. *Two Witches,* ink drawing, 12.5 x 8.5 cm, Museum Boymans Van Beuningen, Rotterdam

Nor would it be implied that the mind surrendered is as capable of the great statement as the mind controlled. It would be said that the power of the imagination is unlimited; not only capable of a reproductive function, forming images of things once seen but now absent, it is also capable of an inventive or creative function, forming images of things never seen - actually non-existent.

Fashion and the exigencies of the times decree to what extent the artist operates according to control and rule.

In the case of the artist confined to the reproduction of things seen, immediate contact is made between the artist's mind and that of the viewer.

There is satisfaction for both - for the painter because he or she will be understood - for the viewer who understands. The contact which the inventive artist establishes is more nebulous.

The path from mind to mind is not a closed, but an open circuit. This artist not only reveals to the viewer the processes of the artist's mind, but generates these processes in the viewer's mind.

To repeat the words of A. C. Bradley: "...the specific way of the [inventive] imagination is not to clothe consciously held ideas in imagery; it is to produce half-consciously a matter from which, when produced, the [viewer] may, if he chooses, extract ideas."

With an incredible energy, Bosch produced the matter; he sparked wonder in the viewer's mind.

It is left to the viewer, not to explain what is in the painter's mind, but to examine the wonder engendered in his or her own mind and in doing so, be infinitely intrigued.

Roger Marijnissen invited the reader of his book on Bosch to enjoy the paintings, always keeping in mind that the artist was a "born painter." Bosch dwells on the fears of his time, many of which are of our time, but let us - while appreciating the message, celebrate the artist and not waste so much time and attention on the "riddle" of his work.

56. Detail of the right panel of *The Garden of Earthly Delights: Hell*

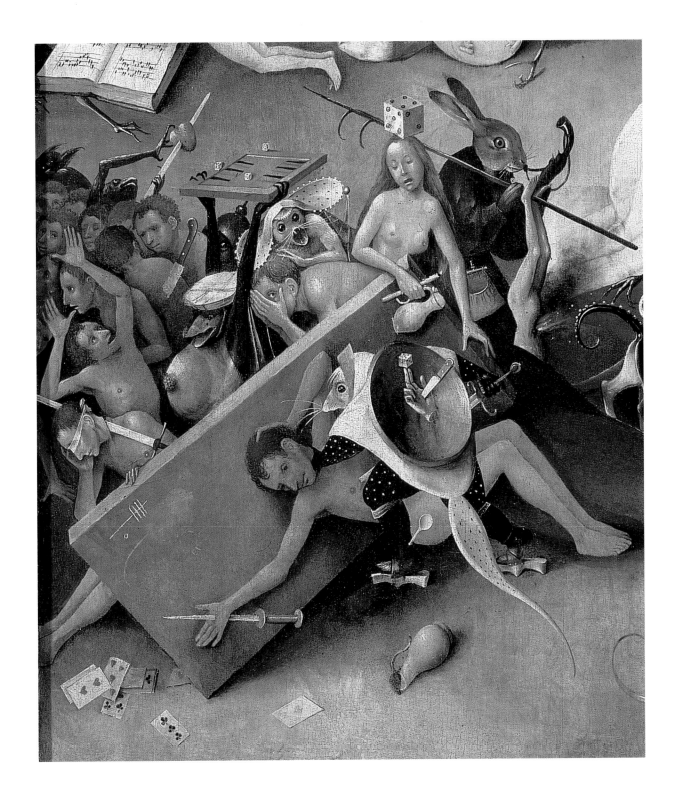

Biography

1453:

Birth of Hieronymus (Jerome) van Aken in 's Hertogenbosch (now Bois-le-Duc). His family, of modest origin, most likely originated from Aken (the last name van Aken literally means "from Aken"), having lived there for more than two generations. There are documents that prove the presence in 's Hertogenbosch of Bosch's ancestors as early as the end of the fourteenth century. His father Anthonius van Aken and his grandfather Jan were painters. We know that Bosch was born into a family of painters and artists, but we know nothing of his training or formal education. We can surmise that he was educated and trained by his family. The nickname Bosch obviously stems from an abbreviation of the painter's place of origin, 's Hertogenbosch.

'S Hertogenbosch is situated in Brabant and is the fourth city of Duchy, established in the fifteenth century. There was no princely residence in Hertogenbosch, as in Brussels, Lille or Louvain, nor were there great noble families comparable to the Nassau of Breda or other patrons from the Netherlands. Hertogenbosch lacked the great financial backers apart from those who lived in the city itself who, in spite of their activity, could not rival the other greater cities of Duchy.

1474:

Date of the first mention of Hieronymus in records. It concerned a transaction done with his sister. He is mentioned as a painter for the first time in 1480.

1481:

He marries Aleyt van den Mervenne, a rich aristocrat. We do not know if the couple ever had children. Aleyt survived her husband and died between 1522 and 1523 at an old age, which we know because she was almost twenty years older than the painter.

1486:

From this date onwards, he is cited as a member of the *Brotherhood of Our Lady*. Membership to this brotherhood was already a long family tradition because certain members of the van Aken family were members as early as the end of the fourteenth century. The number of brotherhoods in honor of the Virgin increased throughout the thirteenth and fourteenth centuries. The majority of the cities in the Netherlands soon had their own proper brotherhood. In Bosch's time, the number of men and women registered at Hertogenbosch's brotherhood had become substantial.

The goal of the brotherhood was essentially the devotion of Mary and occasionally the distribution of aid to the poor.

This pious institution played an important role in the city, less from a religious than from an artistic and social point of view. In effect, the brotherhood would commission a number of works from local artists and exteriors for the decoration of the chapels. Two painted leaves from the restoration of a work by van Wessel around 1475-1476 are attributed to Bosch. He did several works for the *Brotherhood of Our Lady*.

1493-1494:

He drew up the plans for the stained-glass windows and collaborated in the execution of a panel with the names of the brotherhood's members.

1504:

Philipp the Beautiful, Sovereign of the Netherlands and King of Castille, commissions *The Last Judgement*.

1508-1509:

He does the gilt and polychrome decoration of a restoration for the chapel of the *Brotherhood of Our Lady*. He also does the model of a cross (1511-1512).

1516:

Death of the painter in 's Hertogenbosch.

LIST OF ILLUSTRATIONS

1. Death of a Miser p.4
2. Cure of Folly, also called
 The Extraction of the Stone of Folly p.6
3. Anonymous, Portrait of Hieronymus Bosch, c. 1550 p.7
4. The Conjurer p.8
5. Ship of Fools p.10
6. Pieter Jansz Saenredam, Drawing of Bois-le-Duc p.11
7. Allegory of Gluttony p.12
8. Cripples p.14
9. The Epiphany or The Adoration of the Magi p.15
10. The Epiphany or The Adoration of the Magi p.16
11. Martyrdom of Saint Julia p.17
12. The Crowning with Thorns p.19
13. Exterior view of Christ Carrying the Cross p.20
14. Christ Carrying the Cross p.21
15. Christ Carrying the Cross p.22
16. The Adoration of the Magi p.24
17. The Garden of Earthly Delights, open p.26
18. The Garden of Earthly Delights, center p.28
19. The Garden of Earthly Delights, exterior view p.29
20. Detail of the right panel of
 The Garden of Earthly Delights p.30
21. Detail of the Garden of Earthly Delights p.31
22. The Man-Tree p.32
23. Singers in an egg p.32
24. Singers in an egg p.33
25. The Hay-Wain, open p.35
26. Detail of the central scene of the Hay-Wain p.36
27. Detail of the left panel of the Hay-Wain: Eden p.38
28. The Hay-Wain, open p.40
29. John the Baptist p.41
30. The Marriage at Cana, c. 1561 or later p.42
31. Saint John on Patmos p.43
32. Saint John on Patmos, exterior view p.44

33. Ascent of the Blessed to the Heavenly Paradise p.46
34. Ascent of the Blessed to the Heavenly Paradise p.48
35. Hermit Saints Triptych,
 left inside panel: Saint Anthony p.50
36. The Temptation of Saint Anthony p.52
37. The Temptation of Saint Anthony, left panel p.54
38. The Temptation of Saint Anthony, right panel p.54
39. The Temptation of Saint Anthony, exterior view p.55
40. The (little) Temptation of Saint Anthony p.57
41. The Temptation of Saint Anthony p.57
42. The Hardships of Job p.58
43. The Last Judgment p.59
44. Saint Christopher p.60
45. The Hardships of Job, exterior view p.61
46. The Last Judgment, c. 1482 p.62
47. The Last Judgment, c. 1482, exterior view p.64
48. Fragment of The Last Judgment p.65
49. Two monsters p.66
50. Man without body and one monster p.67
51. Pieter Brueghel the Old (1528 - 1569):
 The Triumph of Death p.69
52. The seven deadly Sins in a Peel of terrestrial Globe p.70
53. Ecce Homo p.73
54. Ecce Homo p.74
55. Two witches p.75
56. Detail of the right panel of The Garden of
 Earthly Delights: Hell p.77